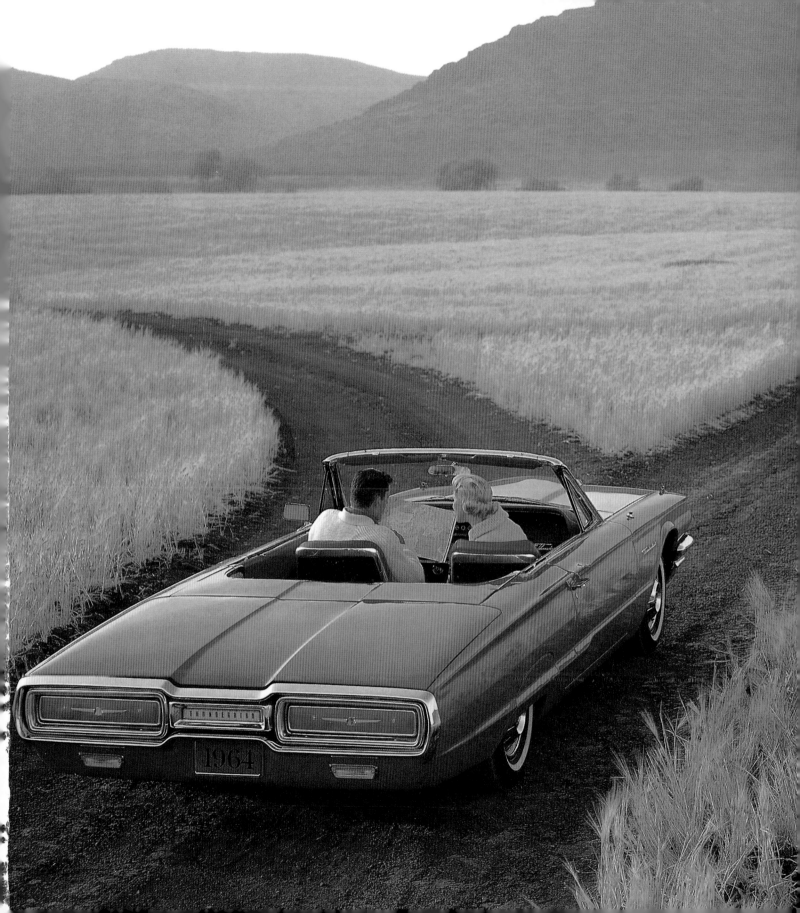

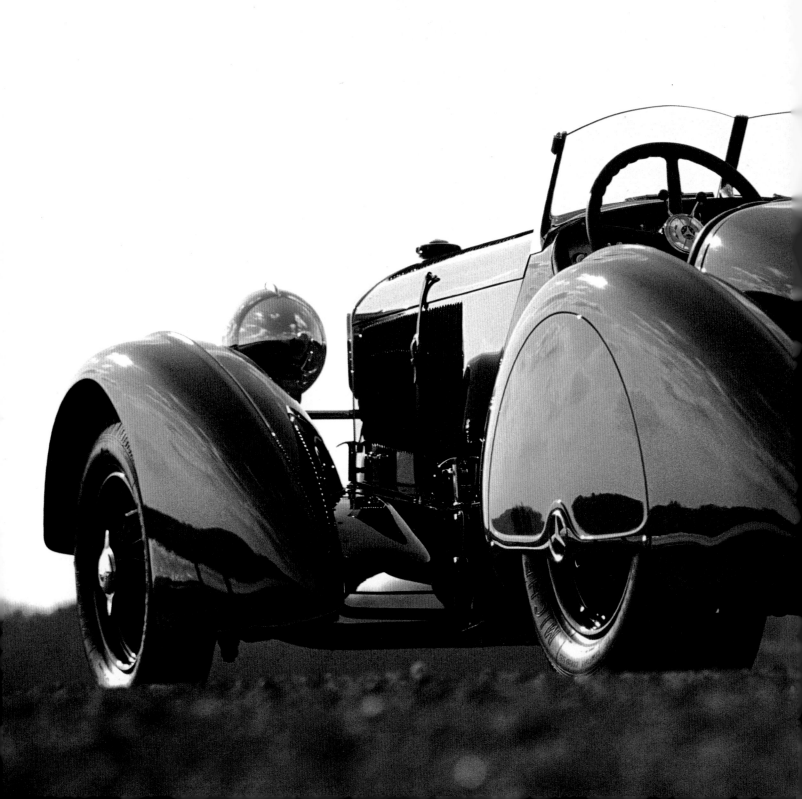

the Convertible

Roma·3
3253

CHRONICLE BOOKS
SAN FRANCISCO

AN ILLUSTRATED HISTORY
OF A DREAM MACHINE

Ken Vose

FOR CHRIS AND NORA,
MY CABRIO-LADIES

Right: Grace Kelly and Cary Grant in a
Sunbeam Alpine overlooking Monte Carlo in
the Alfred Hitchcock classic, *To Catch a
Thief* (Paramount Pictures, 1955).

Page 1: An idyllic scene featuring a 1964
Thunderbird, typical of the automotive adver-
tising of the Boulevard Photographic studios.

Pages 2–3: The Ralph Lauren "Trossi" 1930
Mercedes Benz SSK.

Page 6: Alain Levesque, *La Tournie des
Chateaux*, 1995. (l'art et l'automobile
Gallery, New York)

Endpages: Design for Packard convertible
coachwork by Brunn and Co., 1939. (l'art
et l'automobile Gallery, New York)

Page 115 constitutes a continuation of the copyright
page.

Library of Congress Cataloging-in-Publication Data:
Vose, Ken.
 The Convertible / Ken Vose.
 p. cm.
 Includes bibliographical references and index.
ISBN 0-8118-2447-0
1. Automobiles, Convertible—United States—History.
 I. Title.
TL23.V67 1999 98-49585
629.222—DC21
 CIP

Printed in Hong Kong

Designed by Shawn Hazen

Distributed in Canada by Raincoast Books
8680 Cambie Street
Vancouver, British Columbia V6P 6M9

10 9 8 7 6 5 4 3 2 1

Chronicle Books
85 Second Street
San Francisco, California 94105

www.chroniclebooks.com

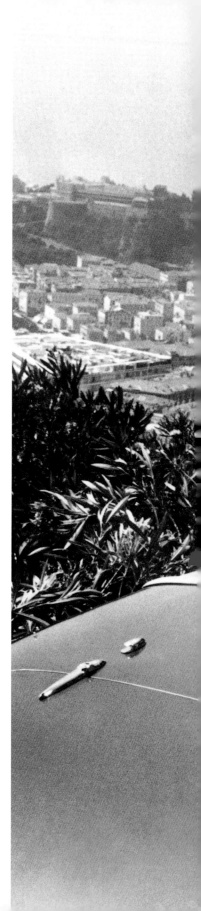

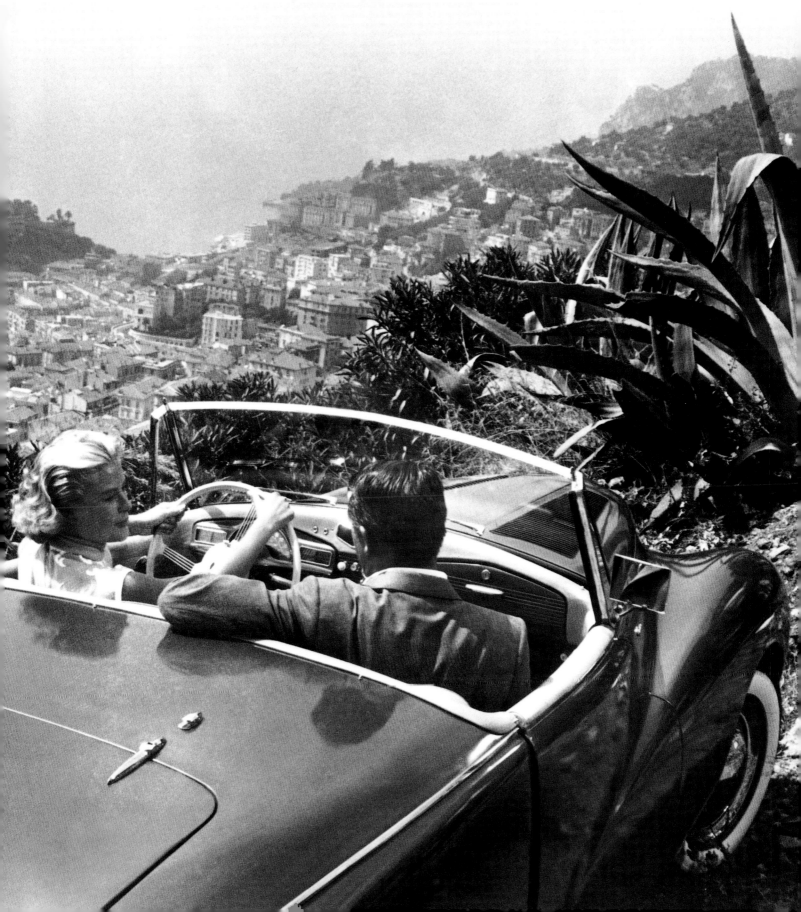

TABLE OF CONTENTS

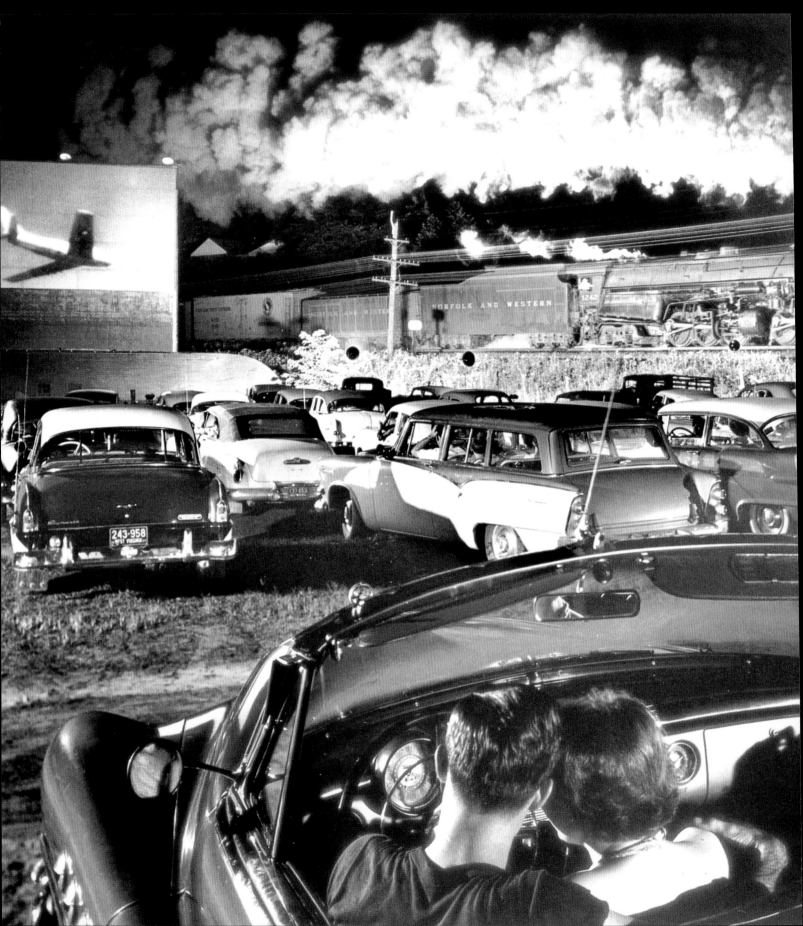

Free to Be

Introduction

con . vert . ible

1. Something that can be converted: *a convertible sofa bed.*
2. Having a top that can be folded back or removed: *a convertible automobile.*
3. Able to be changed *(into* or *to* something else).
4. Able to be converted to a religion, belief, opinion.
5. Able to be turned to a particular use or purpose.

Convertible. A simple word for such a complicated concept. Something that exists as one thing and yet can be transformed, or converted, into something substantially different. For many people of a certain age, the word *convertible* will always bring to mind a young girl effortlessly turning a living room sofa into a bed. The Castro Convertible was a more modern version of the pull-down Murphy bed, which was probably a more modern version of something else. People always have been fascinated by the idea of converting objects or even, as in alchemy, substances into something else. One need only walk through any large toy store to see just how much our kids love to play with things that transform themselves into something different.

Though the convertibles we are concerned with here are of the automotive variety, even within this grouping there is plenty of room for confusion. Is a roadster a convertible? What about a cabriolet, drophead, or landau? Worse yet, what about a car that converts into a boat, such as the amphibious Amphicar? Or, going beyond all reason, the ambiguous Aerocar, whose very name tells you not to sign up for any test drives.

All of these can, with some justification, be considered convertibles. They will be included here, along with other self-propelled vehicles that

Above: Drawing by Peter Steiner; © The New Yorker Magazine, Inc.

Opposite: Neither steam trains nor planes appear to distract this open air couple in a set-piece showing American icons, coming and going. O. Winston Link, *Hotshot East Bound at Iaeger, West VA. N & W*, detail, 1956. (From the collection of Terry and Eva Herndon)

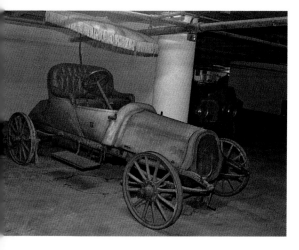

Above: The designer of the 1907 Aerocar, seen here in a storage vault at the Petersen Museum in Los Angeles, was one of the first to find a solution to the "convertible" problem. The Aerocar, which advertised itself as "The Car of Today, Tomorrow, and for Years to Come," was manufactured from 1905 to 1908.

Below: Anna Mary Robertson Moses, *Old Automobile*, 1955, © 1983, Grandma Moses Properties Co., New York. (From the collection of Terry and Eva Herndon)

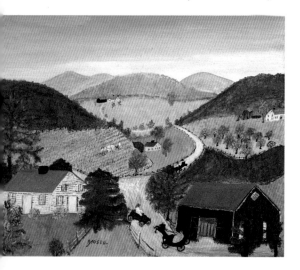

can be driven on the road and have some mechanism for allowing their occupants to sit out in the sunshine, yet recognize that into each life some rain must fall.

The car was gliding gently toward us along the walk. It was a convertible, a '38 Packard Super Eight, and it was the most beautiful car I'd ever seen. It was green—but a deep shimmering green that made you think of antique armor, or the carriages of European royalty. Its hood was outrageously long, its gleaming, angular utterly distinctive radiator grill was like a ship's prow, an image heightened by the slender, vertical louvers and the rakish tilt of the two-panel windshield, which flashed and flashed in the sun. The fenders swept down and away magnificently, the twin side-mounted spares rode in the hubcaps stamped with the scarlet hexagon of Packard. The canvas top was down, the fold-down luggage rack held a trunk splashed with the labels of a dozen foreign hotels, the back seat was a gorgeous jumble of matching Louis Vuitton luggage, tennis rackets in presses, a fencing mask and foils. It was a dream of all convertibles ever made, and it had stopped at our entry.

The quintessential convertible as described by Anton Myrer in his novel, *The Last Convertible,* captures perfectly the impact they can make on the senses; but do they make sense in any sort of practical way? Probably not. They certainly fall somewhat short when it comes to safety. With the exception of the newer Mercedes models and several other high-end vehicles, convertibles offer no protection whatsoever should you suddenly find yourself looking up at the highway. Then there's all of the stuff that nobody bothers to mention as they wax rhapsodic about blonde tresses billowing in the summer sun. Stuff like bugs, dirt, diesel fumes, carbon monoxide, and of course, sunburn. Annoying? Yes, but hardly enough to make a true ragtop lover yearn for a sedan. Convertibles are about pure visceral experience. If you want to feel like Fred Astaire you don't wear sensible shoes.

As one of our best automotive scribes, Pete Lyons, puts it:

An open car is a holiday car, a going-out-just-for-fun car. Dropping the top is like loosening the tie, kicking off tight shoes, hiking the skirt to cool the legs. There's a spicy tang of scandal about the open car.

Showing yourself in one is sort of an in-your-face gesture of defiance at the granite-minded old Puritans who still haunt our deeper dreams.

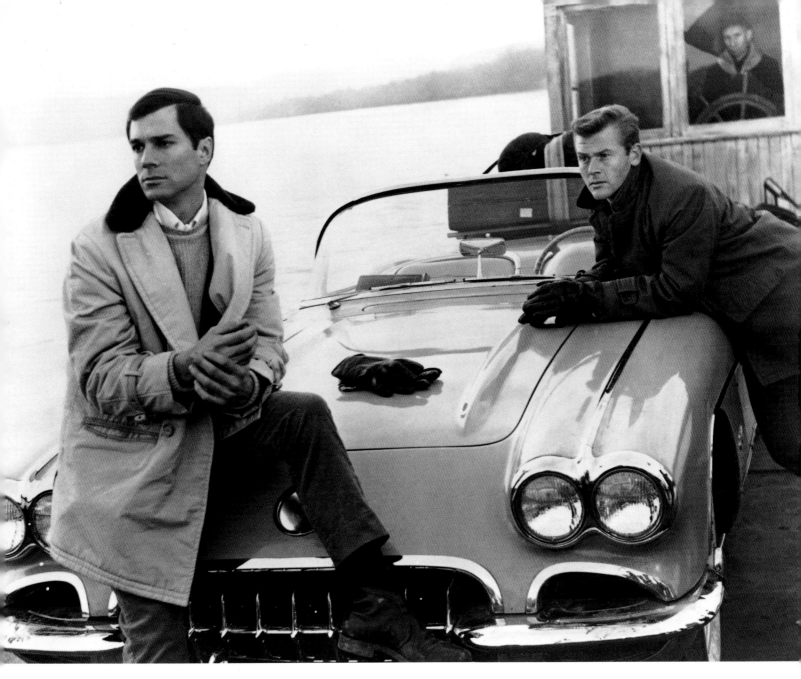

From the moment the first of those fifteen million Model-T Fords rolled off the assembly line in Detroit, the automobile began to be perceived as the birthright of every American. Having a car also has meant acquiring yet another inalienable right, one not considered by the founding fathers: the right to move on, to hit the road, to leave it all behind (or take it all with you), and motor west on the highway that's the best. One highway even had its own television series for three seasons back in the early 1960s, *Route 66*. When Martin Milner and George Maharis set out

George Maharis, Martin Milner, and their trusty Corvette sidekick in the 1960s television show *Route 66* (Screen Gems).

11

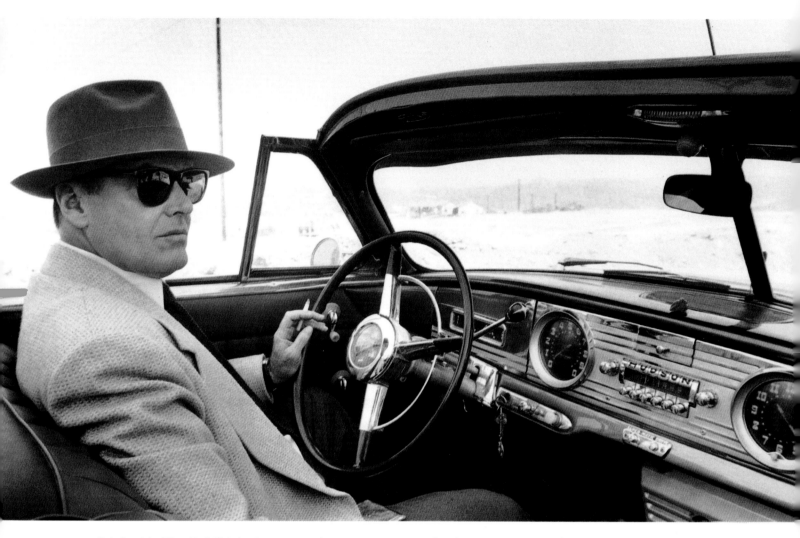

Detective Jake Gittes (Jack Nicholson) plying his trade in a Hudson convertible in *The Two Jakes* (Paramount Pictures, 1989).

in that ragtop Corvette for their weekly dose of adventure, their baggage included the dreams of millions of couch-bound viewers. Viewers who longed for the freedom to motor west the way Buzz and Tod did, out in the open for all the world to see. The freedom that only comes once the top goes down.

Driving a convertible means more than just freedom of movement. It's also the freedom to enjoy the great outdoors on an equal footing with the richest of the rich. Put the top down on your beat-up-mobile, and the sun on your face is identical to that shining on the guy over there in the Lamborghini Diablo. Liberty *and* equality. What could be more American?

The quest for what has become an ever more elusive American dream is still with us, but it's no longer a matter of simply moving westward with

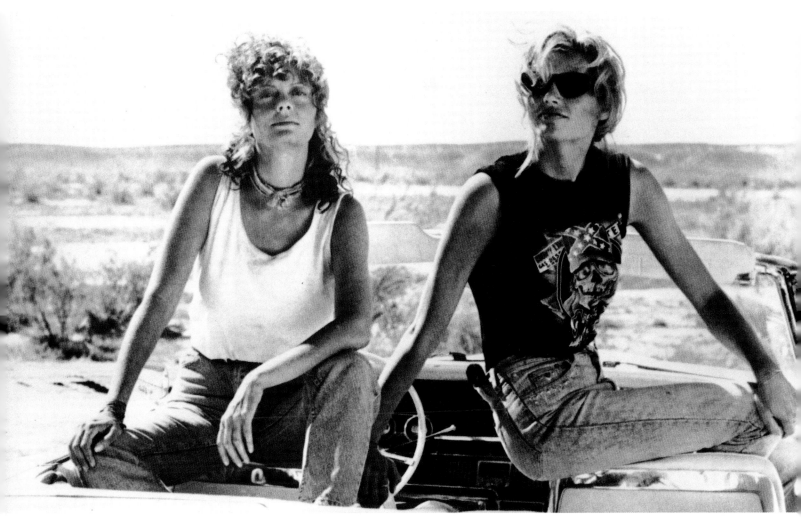

the sun. When the Forty-Niners set off for California in their Conestoga wagons (ragtops), they were probably moving about as fast as their twentieth-century counterparts are able to out there on the freeway during rush hour.

For many people, California means Hollywood, and Hollywood means movies, and movies have always had a thing for convertibles. From the roadsters of the silent film to today's Mercedes and Ferraris, they've roared across the screen in countless productions driven by stars such as Clark Gable, Steve McQueen, Paul Newman, Jack Nicholson, and Susan Sarandon. Susan Sarandon? You bet. If Buzz and Tod were representative of their era, then who better for the 1990s than Thelma and Louise?

Susan Sarandon and Geena Davis share a rare quiet moment in their '66 T-Bird in *Thelma and Louise* (MGM/Pathe Entertainment, 1990).

No matter what you think of Thelma and Louise as role models, a road movie about two women having the sort of adventures usually reserved for their male counterparts was long overdue. The fact that they drove a Thunderbird convertible might seem an overly obvious visual metaphor for freedom, but try to imagine what the film would have been like if they'd hit the road in some tiny, practical econobox. Did the fact that they drove around in a convertible help to make the picture a huge commercial success? Didn't hurt.

Back in the 1920s there was a car called the Jordan Playboy that made a point of selling itself as the sort of a machine you'd want to go west in. Jordan, unlike most other manufacturers, aimed some of their inventive advertising directly at an increasingly independent American woman.

Contemporary print and television advertising aimed at potential convertible buyers often tries to evoke a time when you could actually climb into your Jordan Playboy and get away from it all. In reality, today's convertible driver is likely to be carrying a beeper, cell-phone, and global

MGM starlet Sally O'Neil and her Jordan Playboy.

positioning satellite unit. They may indeed be going west. They may even have the top down. But unless they're driving something from *Back to the Future,* they're headed for a much different sunset than the one that beckoned that "bronco-busting, steer-roping girl" seventy-five years ago.

While freedom may, for some, be just another word for nothing left to lose, it is also a word, and a concept, that invokes nostalgia. The convertible symbolizes freedom, and it is a moving field of dreams. If you doubt that, just take a look at all the middle-aged guys tooling around in the open air. Some may be trying to recapture their youth, but a lot of

FROM *SECOND CHANCE*
by Jack Finney (1986)

When I swung onto the road—there are a lot of big old trees all along it—I began to feel better. And I just ambled along, no faster than thirty, maybe, clear up to the broken stretch before I turned back toward Hylesburg, and it was wonderful. I'm not a sports-car man myself, but they've got something when they talk about getting close to the road and into the outdoors again—the way driving used to be before people shut themselves behind great sheets of glass and metal, and began rushing along superhighways, their eyes on the white line. I had the windshield folded down flat against the hood, and the summer air streamed over my face and through my hair, and I could see the road just beside and under me flowing past so close I could have touched it. The air was alive with the heavy fragrances of summer darkness, and the rich nostalgic sounds of summer insects, and I wasn't even thinking, but just living and enjoying it.

One of the old Playboy advertisements, famous in their day, calls the Jordan "this brawny, graceful thing," and says, "It revels along with the wandering wind and roars like a Caproni biplane. It's a car for a man's man—that's certain. Or for a girl who loves the out of doors." Rich prose for these days, I guess; we're afraid of rich prose now, and laugh, in defense. But I'll take it over a stern sales talk on safety belts.

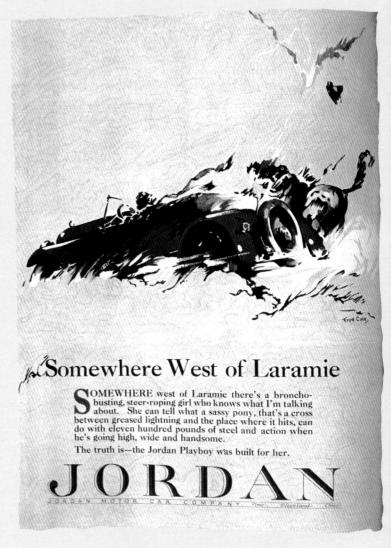

A 1923 Ned Jordan ad for the car bearing his name.

them just happen to love convertibles. Whatever they're up to, a lot of them are doing it with the top down.

But to cash in on memories, you first have to seed them. So automobile manufacturers must grab their buyers early, luring them while they're young, creating the sense of nostalgia that will ensure another convertible purchase to mitigate the effects of hitting that midlife wall. Could all those slick commercials and ads showing happy yuppies breezing through life with the top down actually be intended to sell two cars, one now and one twenty-five or thirty years later? The mind boggles.

Statistics for the past couple of years show convertible sales increasing at about 20 percent per annum. Why this strong resurgence after a decade of steady but unspectacular numbers? According to the *New York Times*:

> *Chalk it up to global warming, or to a collective midlife crisis as baby boomers enter their 50s. Or credit the auto industry with improvements that make these fair-weather friends reasonably agreeable even in the driven snow. Whatever the reasons, convertibles are having a renaissance.*

Four decades of convertible advertising. They may be different cars from different eras, but they're all selling the same dream; although Chrysler did seem to be hedging its bets by placing a faux convertible next to the real one.

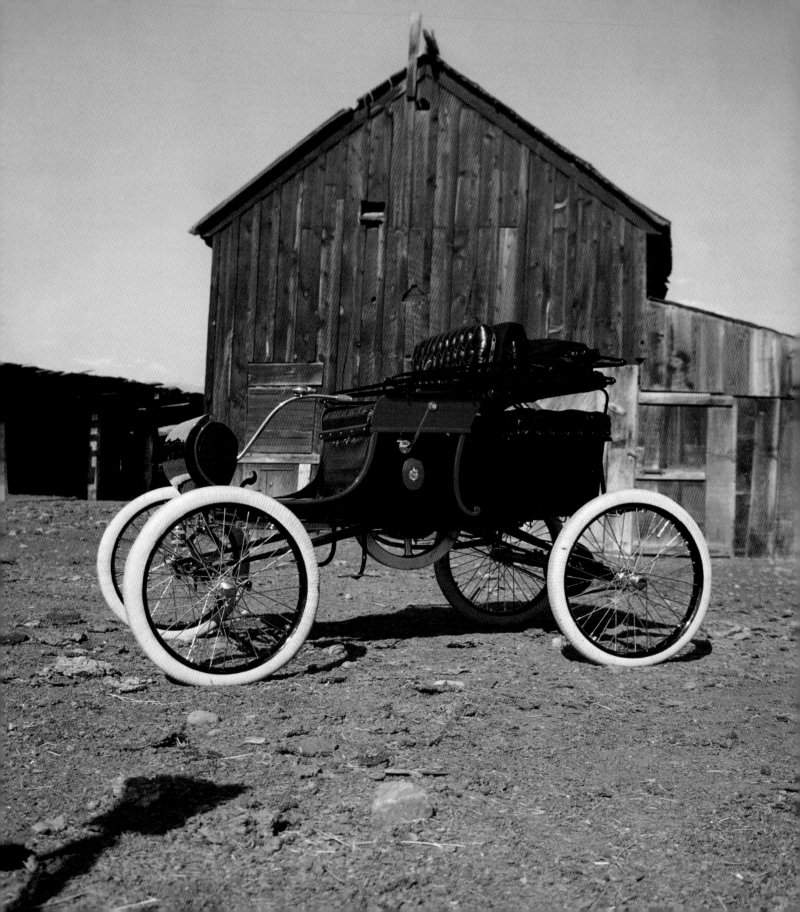

Ragtop Revolution

1898–1969

1 8 9 8 — 1 9 2 8

In the beginning there were no convertibles. There were no coupes or sedans either for that matter. Cars, or more accurately, horseless carriages, had no tops at all. When the first automobiles, like the curved dash Olds, appeared on what passed for roads near the turn of the century, they were not called horseless carriages without good reason. In fact, when they broke down (a regular occurrence) and a horse was called upon to tow them away, the coupling of the two looked perfectly normal.

Despite all that has been said over the years about the fear and loathing that greeted these first crude vehicles, they were a welcome alternative to the twenty-five million horses they were soon to replace. Owning a workhorse back then was no easy job. They had to be fed, shod, and kept healthy; and then there was the smell. Fumes from gas and oil might give off an unpleasant odor, but the stench of the estimated 60,000 gallons of urine and millions of pounds of the stuff that sticks to your shoes deposited on the streets of New York City each day in the late 1890s could have made a motorist of anyone. Well, maybe not anyone. This bit of verse from a 1900 issue of *Woman's Home Companion*, called "To a Horseless Carriage," seems to be firmly on the side of old Dobbin:

> *Avaunt! Thou horridest of modern things!*
> *Vamoose! Unto thy ugly self take wings!*
> *Think not with all thy grand and glitter course*
> *Thou'll e'er supplant that best of friends, the horse.*

As the car evolved and improved it began to gain an identity of its own. No longer just a carriage without a horse, it was thought of more and more as an automobile. Although unlikely as it now seems, even this

THE MOST STYLISH ARRANGEMENT.

Above: Convertible fashion. Designed, one hopes, for passengers.

Opposite: The 1902 curved dash Oldsmobile, a true "horseless carriage."

Above: De Witt Clinton Falls, Untitled, c. 1902. (From the collection of Terry and Eva Herndon)

evolution in nomenclature had its detractors. A *New York Times* editorial in January 1899 came down firmly against this newly imported term:

> *There is something uncanny about these newfangled vehicles. They are unutterably ugly and never a one of them has been provided with a good or even endurable name. The French, who are usually orthodox in their etymology if nothing else, have evolved "automobile" which being half Greek and half Latin is so near to indecent that we print it with hesitation.*

But print it they did, and automobile it would remain.

Right: Frederick T. Richards for Life Publishing Co., *Our Leisure Class Must Be Amused*, 1902. (From the collection of Terry and Eva Herndon)

FROM *THE ANGEL OF DARKNESS*
by Caleb Carr (1997)

Fifth Avenue at the turn of the century.

And as I kept urging Frederick forward past the churches of upper Fifth
Avenue, where the wealthy families of Mansion Row were just leaving
early services, I threw a panic into some people who figured Sunday
morning would be a safe time to stroll absentmindedly across the boule-
vard. I got some angry shouts and even a few curses from those ladies
and gents for splashing horse dung and piss on their Sunday best, and
I threw some feisty words back; but nothing stopped our forward motion,
and we pulled up to the steps of the Metropolitan at just before eleven.

There once was a time when mufflers went on the driver rather than the car.

For the intrepid, early motorist, terminology was undoubtedly less of an issue than meteorology. The inability, or unwillingness, of horseless carriage makers to enclose the bodies of these early vehicles opened the way for the first automotive aftermarket items: clothing for the automobilist. If they didn't want to bake in the sun, freeze in the snow, and soak in the rain, then strong counter-measures were called for.

As late as 1908, when Franklin began offering an optional closed metal body to its line, the majority of cars on the road and in the dealers' showrooms were still open to the elements.

Given the conditions surrounding automobile travel, it is hardly surprising that many, mostly men, considered these early machines unsuitable for the little woman. Any such ideas would certainly have gotten a

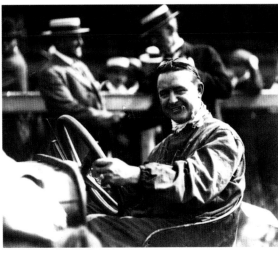

Above: Barney Oldfield, with his ever-present cigar, prepares to go racing in 1908.

laugh from one Joan Newton Cueno of Richmond Hill, Long Island, who not only drove in and completed a number of the arduous Glidden Tours, but managed to scare the hell out of famed racer Barney Oldfield when he rode with her on a race track near Poughkeepsie, New York. It was her prowess in a race car that caused the American Automobile Association to adopt a rule barring women from competing in any of their sanctioned events.

In a 1910 interview in *Outing* magazine, Mrs. Cueno had this to say to aspiring women motorists about the secret of her success: "I took the trouble to learn everything I could about my car myself. I was towed home only once; that was when I let the boiler burn out in my first steamer." She also counseled:

> *Don't rig yourself up in a lot of specially designed apparel for the "lady automobilist," and don't drive as though it were hard work. Whenever I feel nervous or out of sorts I get into my car and drive off my troubles. Since I have motored, I do not know what the inside of a doctor's office looks like.*

Left: Mrs. Andrew Cueno: "I never wear anything more than an ordinary skirt, shirtwaist, and a hat in warm weather, or perhaps a duster cap, and goggles on tour. Add the necessary coat and wraps in winter, and you have all the special costuming any woman needs." (Photo provided by the American Automobile Manufacturers Association)

Mrs. Cueno was made of sterner stuff than most of her contemporaries, male or female. For the majority of motorists, the newer models featuring cloth or canvas tops looked mighty inviting. This fact was not lost on the world's automobile manufacturers.

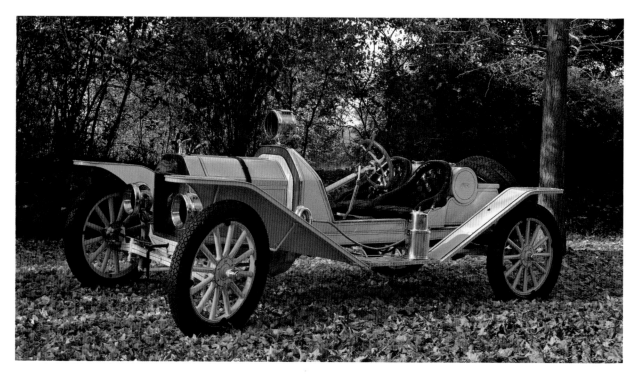

This 1912 Ford Model-T sports a 1960s custom body inspired by the famous Mercer Raceabout.

By 1911 the enclosed car was making itself felt in the marketplace and the U.S. Patent Office began to receive the first of what would soon be a flood of applications. Inventors were convinced that they had discovered the perfect solution for every driving need: a car that had the advantages of both roadster and sedan, the convertible.

While the open touring cars that dominated the automotive landscape were practical in that they could function as either a car or small truck, they were no match for the more expensive closed cars when it came to comfort. The huge canvas tops were more than a handful to operate and the side curtains were even worse. Made of isinglass, or any other material guaranteed to crack and turn a murky brown color, they invariably let in copious amounts of wind, dust, and water. Despite this, the low-priced open touring car accounted for 99 percent of the American market in 1916.

This situation would continue to bedevil the less affluent motorist throughout the teens and early 1920s until the competitively priced Ford

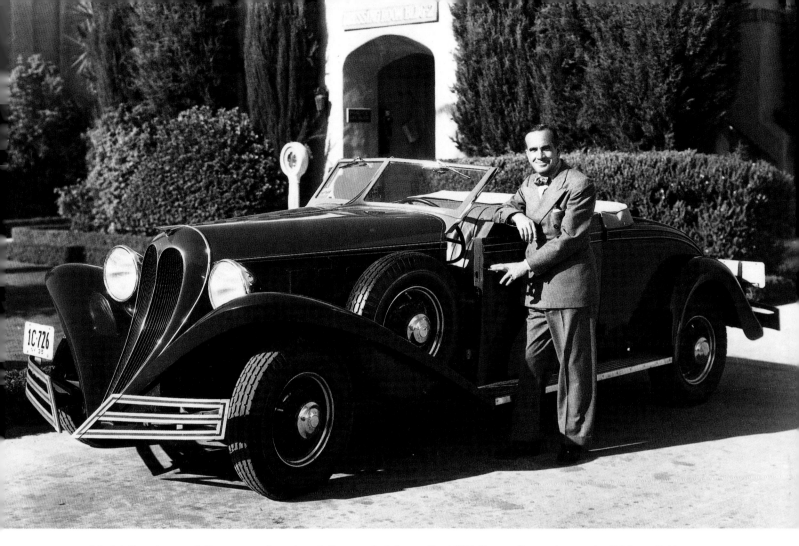

Model-T sedan and Essex coach entered the marketplace. By 1925 the price of the Essex had dropped from an initial $1,495 to a more affordable $795. That year also marked the first in which Americans bought more closed cars than open. But what about the convertible? Did one of the many inventors struggling to perfect the first perfect collapsible top finally succeed? Yes, and no.

The year was 1927—just past the midpoint of the Roaring Twenties and two years before the market crash that led to the Great Depression. Calvin Coolidge, about whom H. L. Mencken said, "the itch to run things did not afflict him," was President. Prohibition was supposed to be the law of the land, but gangsters such as Al Capone were too busy supplying gin to the nation's speakeasies (32,000 in New York City alone) to notice. Babe Ruth, Jack Dempsey, Bobby Jones, and Tommy Hitchcock were giving sports writers such as Ring Lardner something to rave about. Young literary lions Hemingway and Fitzgerald were the talk of the town. *The Jazz Singer*, starring Al Jolson, sounded the death knell for the silent

Stage and screen star Al Jolson with his custom Brewster. Built on a Ford V-8 chassis at their coachworks in Springfield, Massachusetts, Brewster advertised themselves as "Carriage Builders to American Gentlemen."

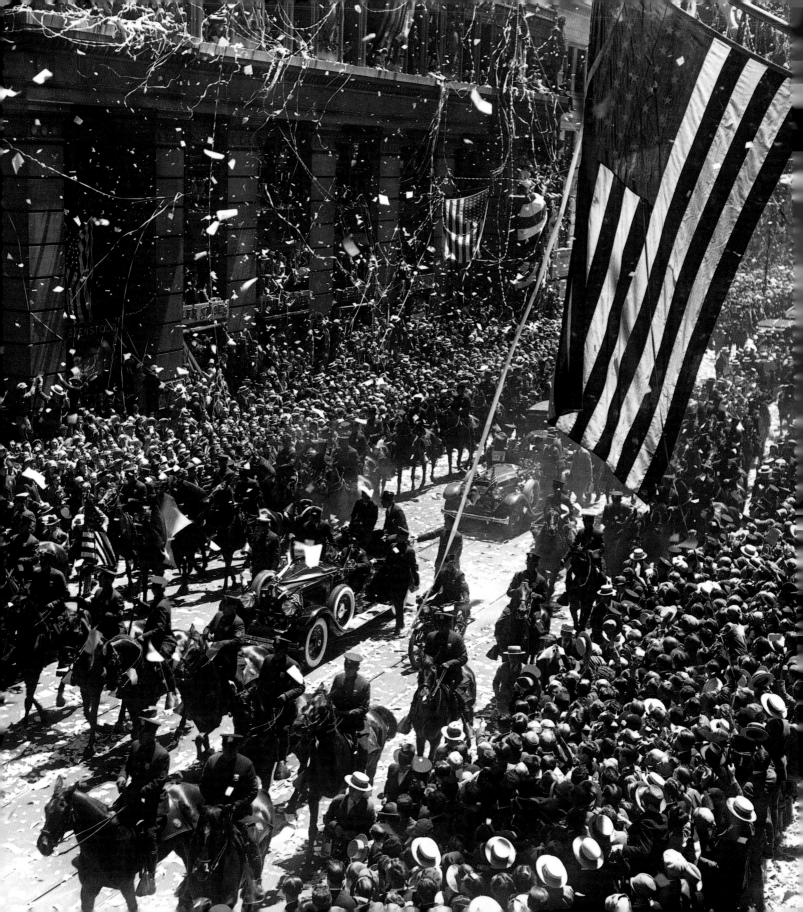

Ragtop Revolution

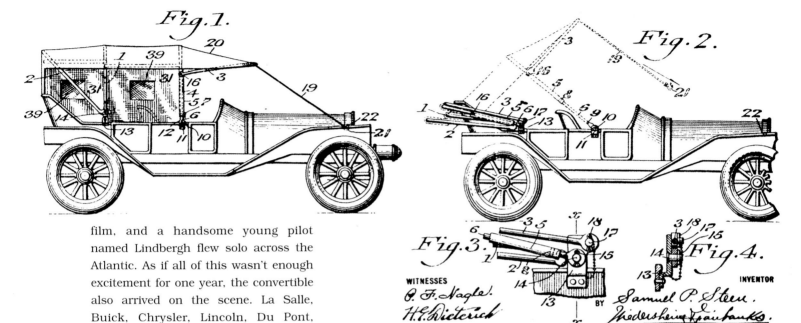

film, and a handsome young pilot named Lindbergh flew solo across the Atlantic. As if all of this wasn't enough excitement for one year, the convertible also arrived on the scene. La Salle, Buick, Chrysler, Lincoln, Du Pont, Stearns, Whippet, and Willys each managed to hit the street with at least one convertible model that year. Auburn, Franklin, Graham, Nash, Peerless, Studebaker, and Packard all followed suit in 1928. As defined by the Society of Automotive Engineers (SAE) in 1928, these were all "true" convertibles in that they had folding cloth tops and roll-up side windows. The convertible had truly arrived.

Above: One of thousands of "convertible" patent applications on file with the U.S. Patent Office, this one from 1914.

1929—1969

Someone once said that a convertible is a compromise between the logic of a hardtop and the emotion of an open roadster; a left-brain, right-brain, Jekyll and Hyde type of vehicle.

Looked at logically, the convertible could not have arrived at a worse time in American history. Within two years the stock market crash would send the world into a tailspin that only a global war could cure. But there is nothing logical about convertibles. Instead of being made obsolete by the Great Depression, the ragtop thrived. For every paper millionaire whose lost fortune led to a long walk off a short pier there was someone with the $3,000-plus necessary to purchase a new Cadillac, Cord, Pierce-Arrow, or Packard; and the car of choice among the eternally wealthy was often a convertible.

At the other end of the spectrum there also was a market for ragtops, albeit the $450 kind. Still cheaper to produce than sedans, the Model A

Opposite: During Lindbergh's triumphal return to New York in 1927, he remarked to one of his fellow passengers in the Packard convertible, "The hop to Paris was a cinch compared to this."

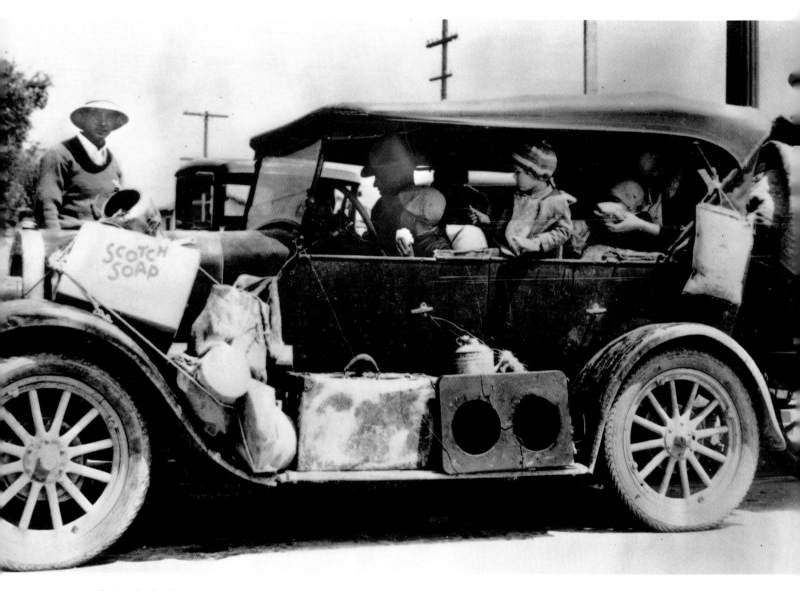

A migrant cotton field worker and his family heading west in hopes of finding a better life.

Fords and their other low-priced brethren carried the desperate, and all their worldly goods, down America's highways in search of work.

At the time of the 1929 market crash, open-top cars, mainly road-sters, accounted for only 10 percent of the overall market while just ten years earlier they had monopolized the industry at 90 percent. By the third year of the Depression, their market share was down to 3 percent, but by this point the "true" convertible had, once and for all, displaced the roadster as the ragtop of choice.

If the convertible had a Golden Age in was undoubtedly the 1930s.

It's remarkable that so many of the cars we now consider to be "classics" should have been produced during this decade of misery. Think of the great convertibles, and you'll picture gleaming machines with mile-long hoods, giant chrome headlights, huge whitewall tires, and hood ornaments the size of a table lamps. Cars with names such as Bugatti, Hispano-Suiza, Delahaye, Delage, or Duesenberg. Marques that have not been manufactured for decades, whose styling owed nothing to computers and wind tunnels, and that were produced in such small numbers by today's standards that many people alive today have never seen them

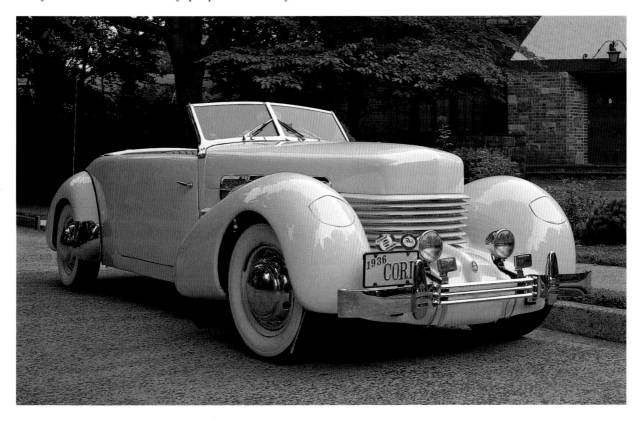

except in books and magazines. These were most definitely cars of the stars. Heroes and heroines of stage, screen, and the nation's sports arenas vied with one another to own the biggest, fastest, and most lavish convertibles that money could buy. Add a touch of European royalty and the odd maharaja and it's easy to see why many of these low volume, luxury-car manufacturer's were forced into liquidation when it became apparent that prosperity was a lot further away than just around the corner. By the end of 1936, the open-top car accounted for less than 1 percent of total automobile sales. But what a glorious 1 percent they were.

1936 Cord Supercharged Convertible Coupe. The Cord convertible was a favorite with the celebrities of the time, including Amelia Earhart, Tom Mix, Sonja Henie, and Johnny Weissmuller.

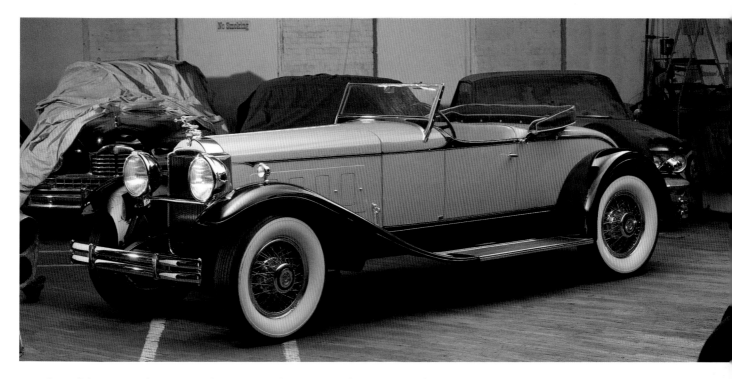

One of these grand marques that managed to survive the 1930s (and on into the late 1950s) was Packard. From its first vehicle in 1899, to the magnificent V-12s of the 1920s and 1930s and the stunning Caribbeans of the 1950s, the name Packard symbolized the finest in American craftsmanship. Those with any doubts could, as Packard's most famous advertising line put it, "Ask the man who owns one."

Among the many celebrities of the time who owned one or more Packards was America's most famous polo player, Tommy Hitchcock. "Not even the effeminate swank of his riding clothes could hide the enormous power of that body—he seemed to fill those glistening boots until he strained the top lacing, and you could see a pack of muscle when his shoulder moved under his coat." F.Scott Fitzgerald's description of Tom Buchanan in *The Great Gatsby* fit Hitchcock like the bespoke clothes he wore. They should, as Fitzgerald is said to have used the polo playing star as the model for his fictional character.

Hitchcock's Packard was a Model 734 Speedster Runabout that he bought new in 1930. Aside from its rarity—less than fifteen are known to exist today—the most interesting feature of the car is that Hitchcock may still own it. Why would that be considered so unusual? Because Tommy Hitchcock was killed during the Second World War while piloting a P-51 Mustang fighter.

Above: The restored Hitchcock/Kanter 734 Speedster.

Opposite: 1922 Bugatti poster by Marcello Dudovich. (l'art et l'automobile Gallery, New York)

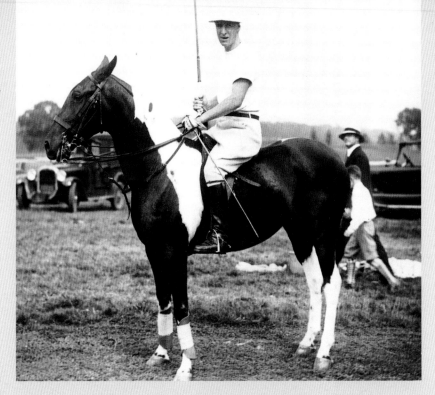

Right: America's greatest polo player Tommy Hitchcock, astride his famous piebald pony, Tobiana, c. 1928.

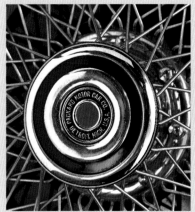

Above: Packard 734 Speedster, wheel detail.

TOMMY, FRED, AND THE PACKARD SPEEDSTER
A True Car Tale

By a widely approved decision of the national polo authorities, Thomas Hitchcock, Jr., has attained that eminence in his particular sport which is shared in others by such men as Tunney, Babe Ruth and Tilden . . . A rapidly growing public for polo now has Mr. Hitchcock as one of those athletes whom the American people particularly delight to honor.

This 1929 *New York Times* editorial confirms Hitchcock's celebrity as one of the top sports figures of the era. Like many of them, he loved fast cars. His car of choice was what many consider the ultimate Packard performance car, the 734 Speedster. A straight-eight engine with dual-throat, up-draft carburetors and a finned exhaust manifold pushed the big machine to a top speed of 100mph. The car, which cost about $5,200, was introduced at the 1930 New York Auto Show. Featuring the finest leather and wood, the car was assembled by the Packard custom shop to coachbuilt standards. Hitchcock would keep it for the rest of his life.

He continued playing world class polo until the 1930s when age and his investment banking workload caused him to retire. As a teenage fighter pilot in World War I, he had flown with the famed Lafayette Flying Corps; now he returned to flying as a way to keep some excitement in his life, and as a business, by starting his own air freight service. Too old to

fly in combat during World War II, he instead helped to develop the Packard-engined P-51 Mustang. During a routine test flight, on April, 12, 1944, his aircraft failed to pull out of a dive, killing him instantly.

Nine months later Fred Kanter was born.

Fred, along with his brother Dan, owns and operates the world's largest repository of Packard parts. It's probably safe to say that one could build a Packard from the ground up without ever leaving their Boonton, New Jersey, facility. Fred, who always has had a passion for anything with the name Packard on it, first saw the Hitchcock Speedster in 1963 when he was a freshman at Lehigh University. It was parked next to the Packard laboratory building, which was named for James Ward Packard, the founder of the eponymously named automobile company. Fred, who already owned two Packards, knew immediately that he absolutely had to have that particular car. The owner named a price that was a good deal more than Fred could afford, so the car went unsold. For the next ten years, Fred kept after the man. Naturally, as it does with all classic cars, the price kept going up. Finally, Fred and Dan had the wherewithal, and the deal was done. The next step was to restore the Speedster to its original condition. That also took a big pile of where-withal, so it wasn't until 1989 that the car received a complete frame-up restoration. By that time Fred knew the history of the car, including the background of its illustrious first owner.

When the restoration was finished, the car was delivered to Fred.

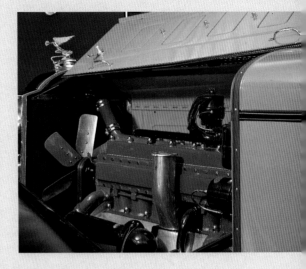

The powerful 145hp Packard straight-eight engine.

I got into the car and drove it up from the street into the garage and sat transfixed in it, wondering what Tommy Hitchcock had felt like the first day he'd gotten the car. Sitting there in the driver's seat, my hands holding the wheel suddenly felt energized, as if electricity was going through them. It was really strange, and at the time I wasn't sure what to make of it. Then, about a year later, I was walking through a tranquil nature preserve in Sweden when it just came to me that perhaps I was, in a former life, Tommy Hitchcock. All of the pieces of the puzzle finally fit together. How had I found the car? Had I come back just to find it? There seems to be a reason that I have the Speedster, a strange connection between me and the car. Who knows what it really is? Or could it be just chance?

Is Fred Kanter Tommy Hitchcock reincarnated? We will never know. But we do know that a great example of America's motoring heritage has been preserved, reincarnated if you will, for the pleasure of generations yet to come.

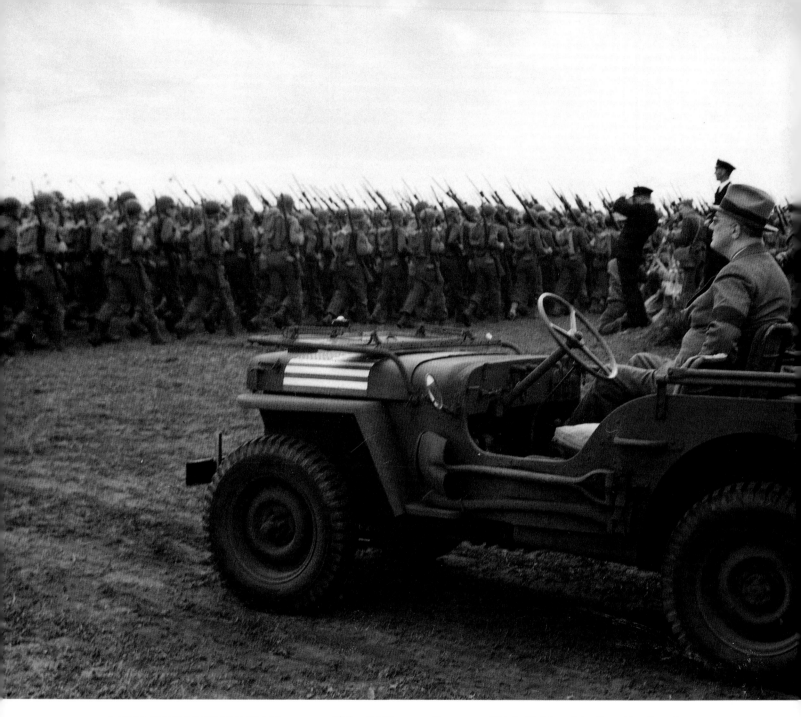

A solemn President Roosevelt reviews the troops in North Africa.

If the 1930s were the convertible's Golden Age, then the decade or so following World War II deserve the "Bronze" title. From the time of the Japanese attack on Pearl Harbor in December 1941, until the 1946/47 model year, there wasn't much happening on the convertible front. Only one ragtop was produced in large numbers. It came in olive drab, battleship gray, or camouflage and was popular enough to survive into the

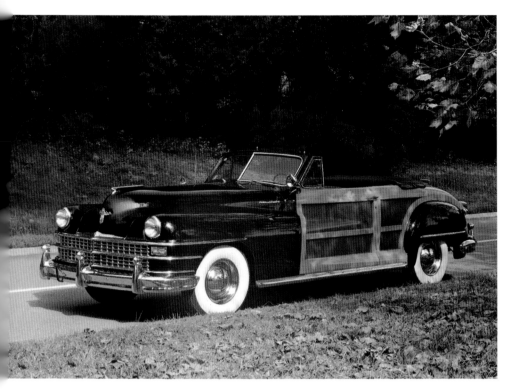

Above: Amilcar with skiff-style coachwork.

Left: 1948 Chrysler Town and Country. Before the Town and Country was phased out more than 9,000 had been sold, many to Hollywood celebrities such as Barbara Stanwyck, Clark Gable, Ray Milland, and Bob Hope. They sold for $3,000 in 1946, and movie stars were among the few who could afford them.

1990s, albeit with a lot more colors to choose from. This true throwback to the runabout era was, of course, the Jeep.

The war years had imposed many restrictions on America's drivers in terms of gas rationing, a 35 mph national speed limit, and prohibitions against any non-military uses of rubber and other vital materials. The end of the war saw potential automobile buyers storm into new car dealerships with the same intensity and purpose of mind recently used at Iwo Jima and Normandy. For returning servicemen, the automobile symbolized the freedom they had fought so courageously for, and no automobile offered up more in the freedom department than the convertible.

Of the first new models available to the post-war buyer, one was destined to become a classic: the Chrysler Town and Country. The car, according to Chrysler, had "the grace and elegance of a yacht. In fact, the wood paneling is quite similar to the planking of a ship both in construction and treatment." It is one of the last vestiges of what was once a popular coachbuilt body option: the wooden skiff. Pioneered by French coachbuilder Jean Henri-Labourdette, the cars were designed and constructed as if they were small boats. These land yachts often featured a boat-tail design that made them seem even closer to their nautical brethren.

Below: The Town and Country's stylish interior.

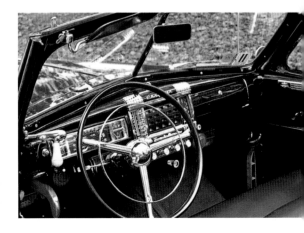

When the Town and Country convertible appeared in 1946, it was an immediate sensation. Custom made by the Boyertown Body Works in Pennsylvania, the eight-cylinder cars featured white ash framing fitted together with interlocking miters and a stunning art deco interior of wood, chrome, leather, and plastic. Perennial cowboy sidekick, Leo

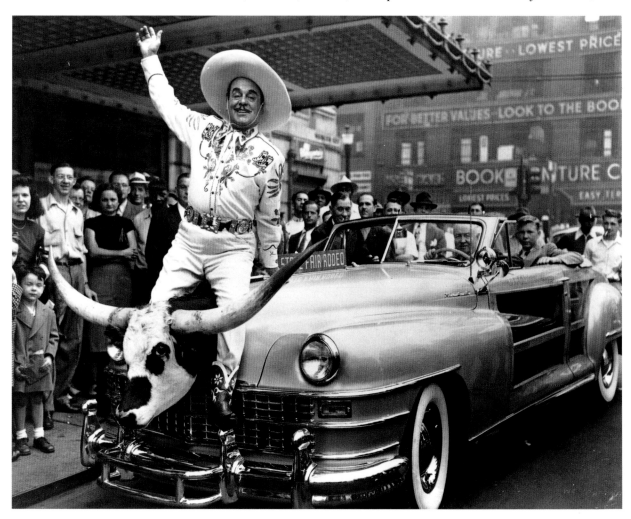

Leo Carillo and his Town and Country. The hood ornament was not a Chrysler option.

Carillo, went them one better by having his fitted out with the head of a longhorn steer, which he would sit astride during parades.

By 1950 every domestic manufacturer had at least one convertible in its lineup, thirty-three separate models in all. But the great postwar boom had reached its apex, and before long the "if you build it they will buy it" mentality of the automakers would no longer suffice. Then, suddenly, there was a new kid on the block, the hardtop convertible. A convertible

RAGTOP POLITICS

When Archduke Francis Ferdinand set out with his wife, Sophie, to take part in a celebratory motorcade through the streets of Sarajevo, he would become not only a victim of the incident that would precipitate the First World War, but the first important personage to be killed while riding in an open car. His assassination on June 28, 1914, did little to reduce the enthusiasm of public leaders for motorcades in which they sat or stood in the back of large convertibles, the better to be adored, scorned, or shot at by the viewing public. In fact, it was only in the aftermath of the 1963 Kennedy assassination that various transparent protective shields, which had existed for some time, began to appear with some regularity on these motorcade convertibles. This type of hybrid vehicle would reach its apogee (or perigee) with the appearance of the Popemobile.

Above: The Archduke Ferdinand and his party prepare to depart for Sarajevo on June 28, 1914.

Far Left: Pope John Paul II and his Popemobile in 1987.

Left: The bubble top that might have changed the course of history had it been in place in Dallas, Texas, on November 22, 1963.

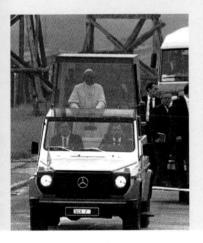

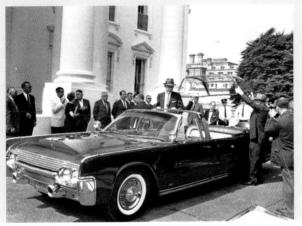

that didn't actually convert at all but looked as though it might. Introduced by General Motors in 1949, these neat looking cars that offered a better, quieter, and most significantly, safer ride, soon began capturing the hearts of many potential convertible buyers.

If the 1950s were a good time for the convertible, they were not so hot for some of the companies that made them: Packard, Nash, Hudson, Kaiser, Frazer, and Willys-Overland all disappeared from the domestic scene during the decade. These were the years of Ike, Russian Sputnicks, U-2s, civil rights, Hugh Hefner, Fidel Castro, Marilyn Monroe, and a young man from Mississippi named Elvis Aron Presley. Elvis, who would soon be described by Leonard Bernstein as, "the greatest cultural force in the twentieth century," had a thing for Cadillacs. Of the many that he would own, and often give away, his favorites were a white 1960 limo with gold records on the ceiling, a pink and white 1955 Fleetwood, and a 1956

An Elvis photo-op for two admirers. The original white paint on this 1956 Caddy was redone in a purple shade, supposedly specified by Elvis's crushing a handful of grapes on the fender. (Used by permission, Elvis Presley Enterprises, Inc.)

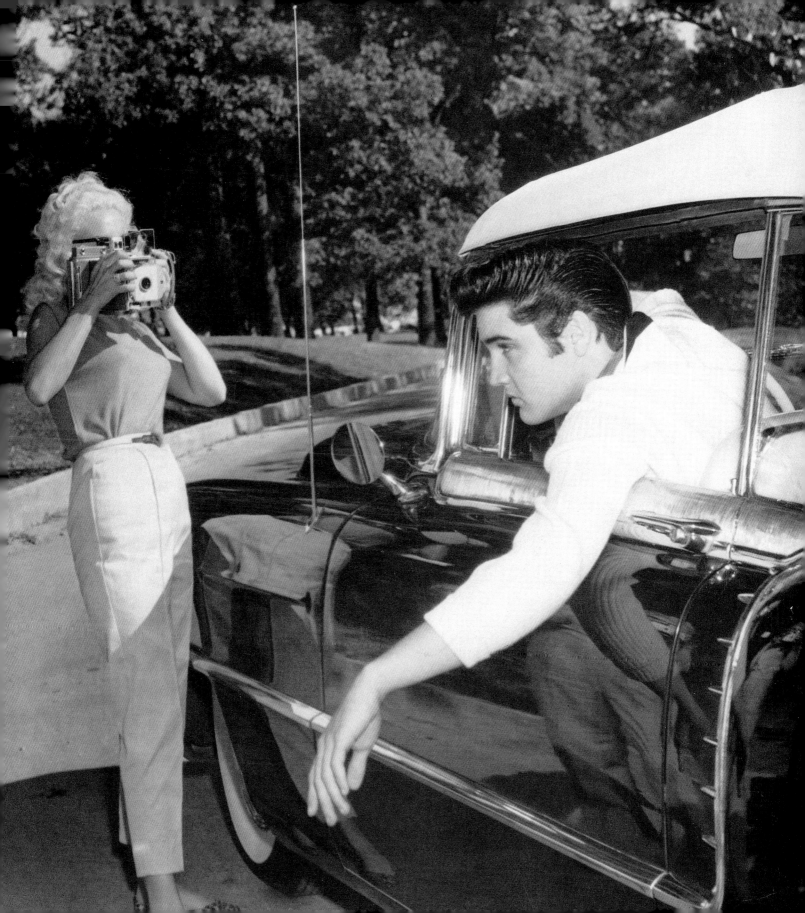

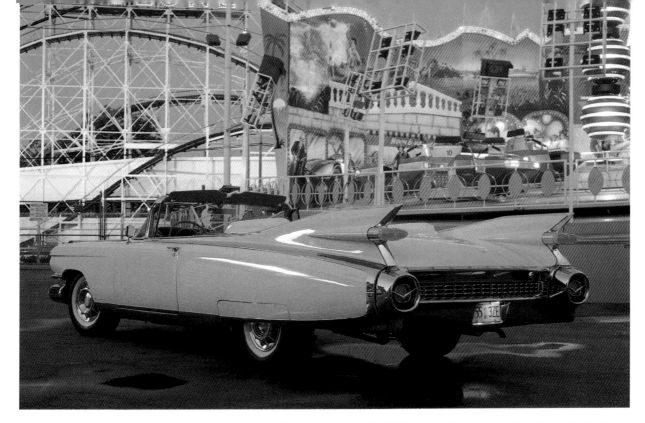

purple convertible. If ever there was a vehicle fit for a rock and roll king, it was the Caddy convertible. Elvis wasn't the only one; Chuck Berry knew it too back in 1955 when he wrote in "No Money Down":

> I want a yellow convertible,
> Fo' do' de Ville
> With Continental spare
> And wire chrome wheels

Long, wide, luxurious, and, most of all, outrageous, the 1950s Cadillac convertibles were like no other vehicles on earth. The Eldorado was, like the country that produced it, the biggest and the baddest, with tail fins worthy of a whale watcher's afternoon. But, as the 1950s turned to the 1960s, the hubris that encouraged such excess would give way to a different way of looking at things. A decade that began with high hopes and a new president who asked people to think about what *they* could do for their country ended in despair with America mired in two undeclared wars, in Vietnam and at home.

The 1960s were, however, good years for the convertible. More than 500,000 were built in 1965 alone. From 1962 through 1966 they accounted for 6 percent of the overall market.

Unfortunately, 1965 also turned out to be the year that sales began to diminish, slowly at first, but by 1969 they barely topped the 200,000

Above: One could be forgiven for thinking that this 1959 Eldorado was simply another amusement park ride.

Opposite: Cadillacs weren't exclusive to the rock-and-roll crowd. Here's the one-and-only Liberace and his one-of-a-kind Caddy convertible.

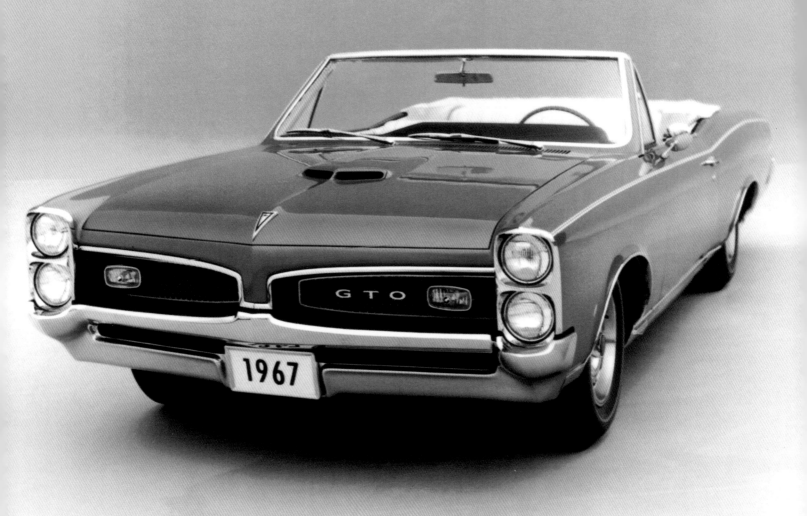

mark. The downward spiral would continue until only one domestic convertible was being manufactured: the Cadillac Eldorado.

Many of the most sought-after convertibles from that era were the various muscle cars built by the Big Three. Cars with names like Boss, Charger, Challenger, GTO, and The Judge. Perfect for the dragstrip, they were brutally quick from a dead stop and faster than the limit in a straight line. Unfortunately, they came up a little short in the handling department. Stopping quickly and maneuvering through the twisty bits were not their forte. For that kind of performance, more and more Americans were turning to the ever-increasing number of European cars arriving on our shores.

Above: 1964 Alfa Romeo 2600 Spider. Sexy styling, in this case by Carrozzeria Touring, coupled with superb road holding were hallmarks of the European ragtop.

Opposite: 1967 Pontiac GTO.

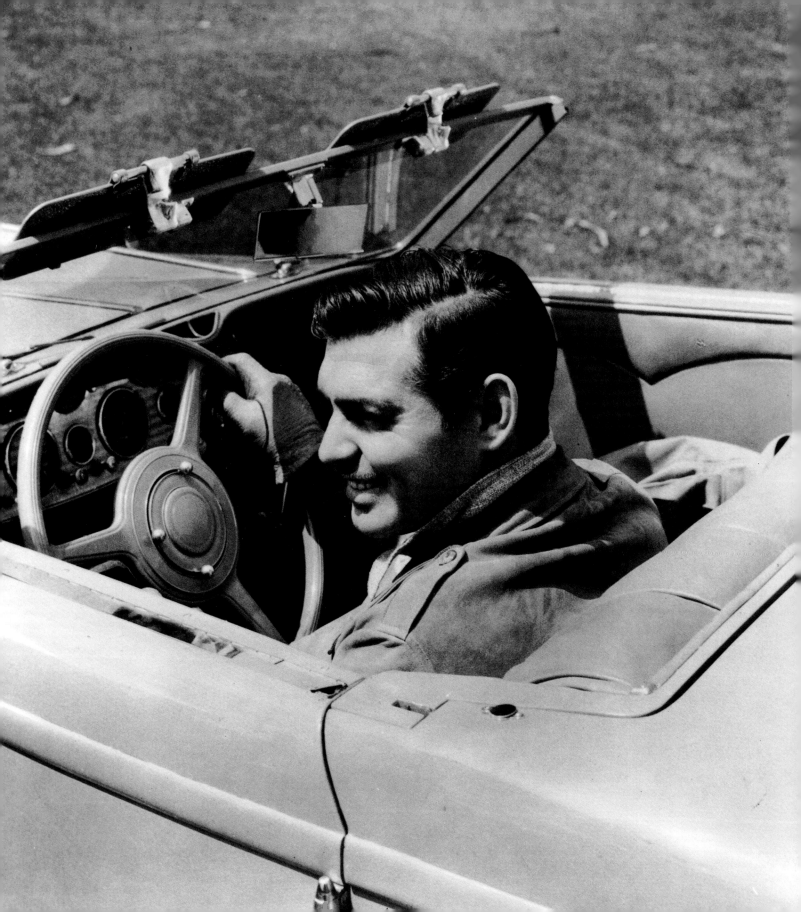

Look at Me 2

Is it a midlife crisis or just a convertible?

The real reason for the continuing popularity of the convertible is obvious to anyone who has ever spent a warm summer's day crusin' with the top down; it's absolutely, positively the most fun way of getting from here to anywhere (or nowhere). You bask in the sun, feel the wind, and no less important, you can see and be seen in a way that just doesn't happen in a closed car. If it's true that blondes have more fun, then blondes in convertibles would seem to have it all. In other words, convertibles are sexy.

Peter Marsh and Peter Collett addressed this point in their book on the psychology of the car, *Driving Passion*:

> *Convertibles communicate their own distinctive messages. For many people they evoke not only the true spirit of motoring but also a sense of youthful freedom and non-conformity. And this applies equally to men and women. The woman who drives a convertible is the woman who doesn't wear a bra. She also wants to be seen, and the absence of a roof serves this purpose nicely. The man, on the other hand, wants you to see the woman he is with as well as himself. Even rather plain people somehow look much more attractive and interesting in a car specifically designed to achieve this effect.*

In his book, *Auto Opium*, sociologist David Gartman makes the case that cars are intentionally designed to remind potential buyers that between the lines of every owners manual lurks a secret sexual subtext:

"And I suppose I should be satisfied just to bask in your glory."

Above: Drawing by Saxon; © The New Yorker Magazine, Inc.

Opposite: Clark Gable at the wheel of his 1935 Duesenberg J Convertible.

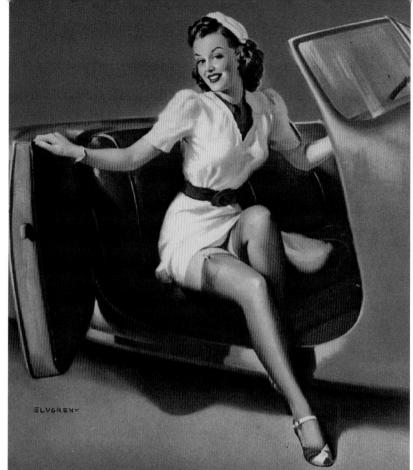

Right: Gil Elvgren, *Sport Model*, c.1943.

Above: Chuck Queener, *California Dreamin'*, 1994.

The excess energy of repressed sexual desire became steered into the pleasure of consumption, and the automobile quickly became one of its commodified outlets. Stylists intuitively appealed to this desire by associating the car with the socially defined space of sexuality—home, leisure, vacation. The sports car was sexy because it was impractical for work and tailored to the realm of leisure extravagance and waste. The convertible was sexy because it was a leisure machine, for top-down, warm weather drives in the country and on vacations.

Cars with plush interiors reminiscent of a living room or bedroom were sexy because they looked like the site of intercourse, the home. Auto stylists thus sought to make cars look sexy by unconsciously drawing on the cultural association of sex and leisure created by Fordism.

All of this talk about sex is not meant to say that driving a convertible is only for delectable young blondes or middle-aged lotharios. Hell, Eleanor Roosevelt drove a Fiat convertible, and famed British author/raconteur Malcolm Muggeridge also liked to tool around with the

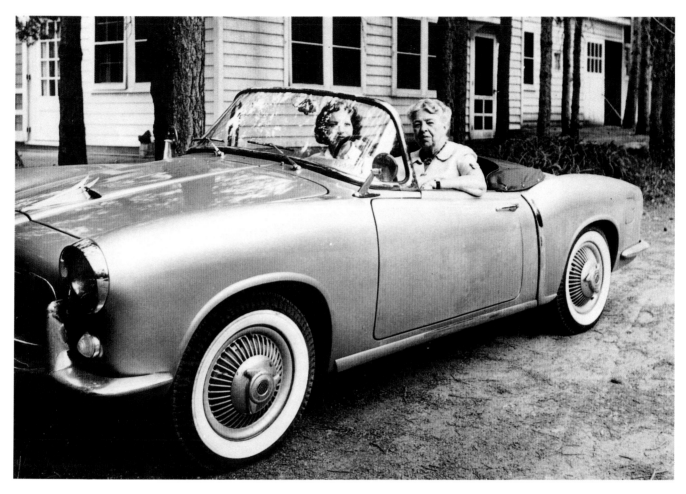

top down until he was well into his seventies. "The car that I use and like is the Triumph Herald convertible. I like cars that open. Often in quite bad weather I open them. I like air."

Although the "glamour impaired" are quite capable of enjoying their ragtops, the image of convertibles that immediately comes to mind is one more associated with the sophisticated French Riviera or Hollywood. There are probably more convertibles per square foot of paved road in and around Beverly Hills than can be found in any other spot on the planet. They are however, for the most part, not being driven by movie stars. In this age of stalkers, kidnappers, and various other nut-cases, the convertible offers neither anonymity nor the sort of bulletproof protection favored by the now ever present security types. While movie stars still drive the latest in ragtop dream machines, they do so pretty much within the confines of the silver screen. This was not always the case.

Eleanor Roosevelt in her Fiat Gran Luce roadster. In 1959 her son, FDR, Jr., became a partner in a racing team that fielded Fiat Abarths in international competition. Eleanor was a strong team supporter, as long as Franklin, who loved racing, didn't do any of the driving.

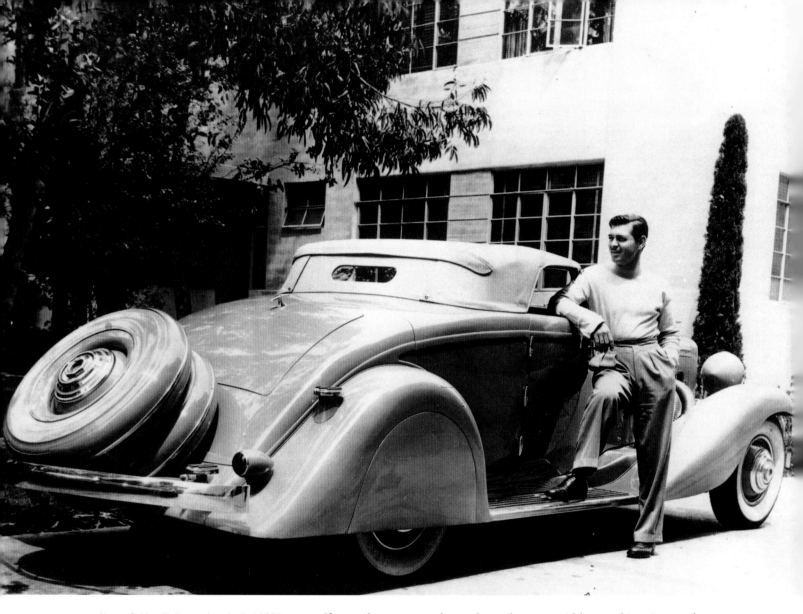

Above: Gable with the newly re-bodied 1935 Duesenberg JN Convertible Coupe.

Opposite: Check your oil, sir? Gary Cooper, like Gable, was not averse to opening the hood of his Duesenberg.

If ever there was a place where the convertible was king it was the fabled Hollywood of yesteryear. From the days of the silent film, through talkies, Technicolor, Todd-A-O, and Tab Hunter, the denizens of Tinseltown loved their drop-tops. And of all the stars and starlets who cruised Hollywood Boulevard with their tops dropped, none were better at it than Clark Gable and Gary Cooper.

Gable, the "King" of MGM, owned some of the world's great convertibles during his long reign, including a 1932 Packard Twin Six, a 1934 Packard Twelve LeBaron, a Rollston-bodied 1934 Duesenberg J, a 1938 Packard Darrin Convertible Victoria, a 1946 Lincoln Continental, a 1949 Jaguar XK120, and finally, a 1957 Mercedes 300Sc cabriolet.

That he loved fine cars was obvious to anyone who knew him. Less

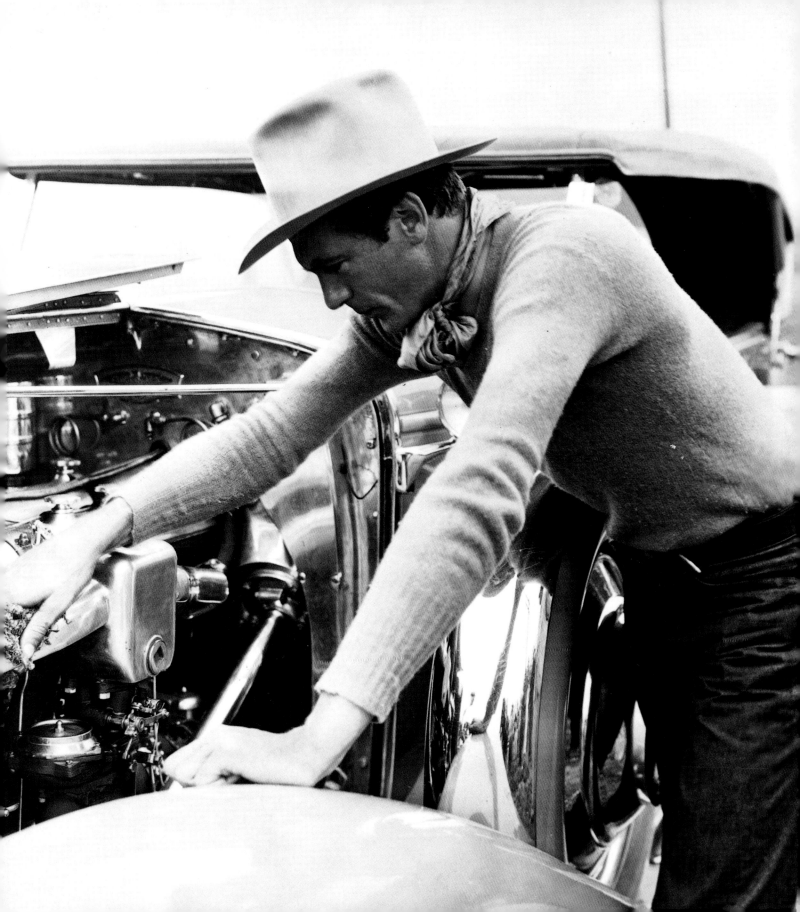

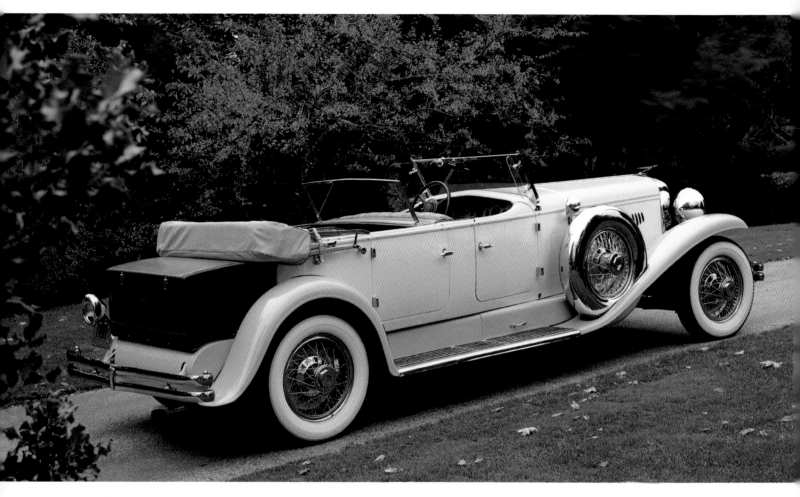

Cooper's 1930 Derham-bodied Duesenberg J Tourster.

obvious was the way he personally took care of them. Some of his contemporaries thought he acted more like your typical grease monkey than a major movie star.

Cooper was another certified gearhead. His Derham-bodied 1930 Duesenberg J Tourster with its striking lime-green and primrose-yellow paint scheme was immediately identifiable as "Coop's" Duesie, especially to the police. In the first three months of 1931 alone, Cooper got four speeding tickets. One of only eight built, this car and the notoriety it immediately attained precipitated what any Hollywood hack worth his salt would dub *Car Wars*.

Cooper loved speed and back in the 1930s there was no better place to go fast than Northern California's Muroc Dry Lake beds. In October 1932 a match race was set up between a Mercedes SSK owned by Zeppo Marx and a short-wheelbase Duesie owned by agent Phil Berg. Coop

First Love. Stanley Wanlass, 1985.

wanted to include his Tourster. Contractually forbidden to race, Coop hired a professional driver to pilot the car. But even with its fenders removed to help improve the airflow, it was no match for the other cars. In the actual race it would be Berg's short-wheelbase version that defeated the SSK belonging to the extra Marx Brother. Then, as now, movie stars were news. The race was deemed important enough to be covered by the *Los Angeles Times,* which ran the story under the headline: "Filmland Stars See Dry Lake Race."

Along with Cooper, Al Jolson, Mae West, Ben Lyon, and the rest of the Hollywood crowd that came to watch the race was Clark Gable. Before long he too had a Duesie. Originally bodied by Rollston, the car was re-bodied by Bohman & Schwartz at Gable's request. This, ostensibly, because it leaked rain all over Carol Lombard on their first date. Within a year he had sold the re-bodied beauty in order to acquire a new and super-rare 400 hp, supercharged Duesenberg Straight Eight. Super-rare, but not impossible to find. Cooper already had one parked in his garage.

Even with the coachbuilt era fading into memory, the two stars continued to buy the latest and fastest that they could get their hands on. For Gable it was mostly Jags, with the odd Thunderbird thrown in, while Coop favored Mercedes-Benz. As he put it, "A Mercedes, I always figure,

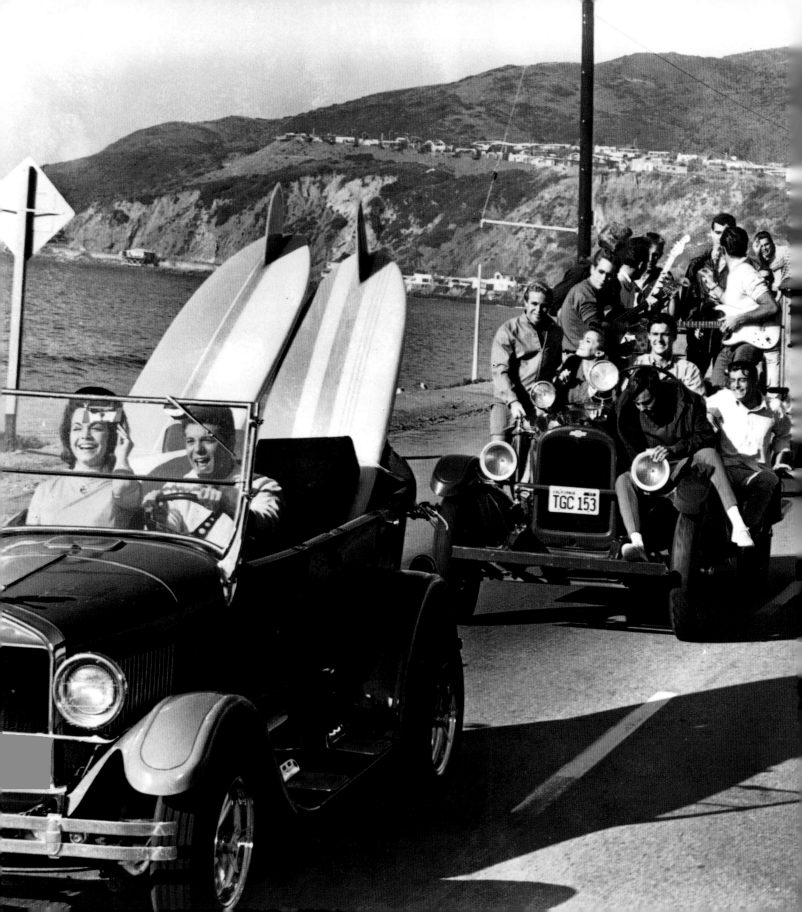

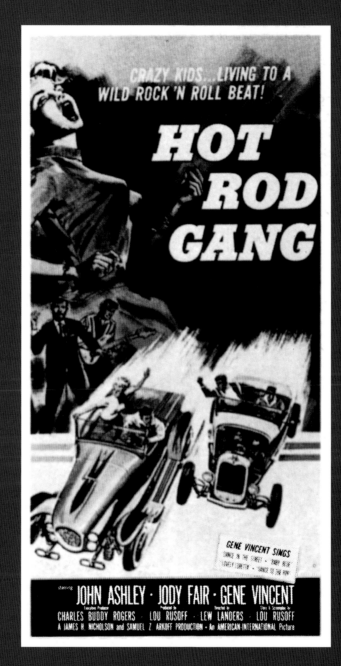

Left: America's (well, American International Pictures') favorite teen couple, Annette Funicello and Frankie Avalon, head for the beach in *Muscle Beach Party* (American International Pictures, 1964).

Above: The plot line for *Hot Rod Gang* (American International Pictures, 1958) runs the gamut from A to B. Boy (John Ashley) needs money to race his rod, so he joins rock star's (Gene Vincent) band.

is the next best thing to a horse." When Coop got a hot new 300SL in 1955, Gable responded in kind in 1956. Gable's last car was a 1957 Mercedes 300Sc convertible, while Coop's was a 1957 Plymouth Fury. The rivalry came to an end with Gable's sudden death in 1960. A year later Coop was gone as well. Actors, of course, still drive, and rivalries do thrive. But, excepting Paul Newman, who would have a tough time finding a worthy sparring partner, it would be hard to imagine such a scenario being played out by any of today's major stars.

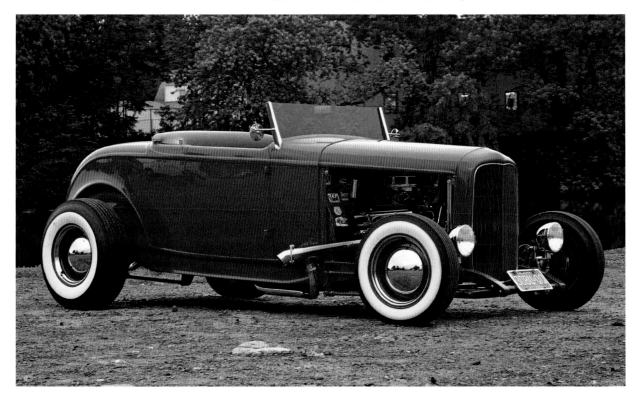

1932 Ford Roadster. The prototypical hot rod.

One subliminal lure of the convertible is a psychological longing to be seen as something most of us probably aren't anymore (or never were). The current resurgence of hot rods and custom cars among men of a certain age is a good example.

The hot rod, as built and raced on the highways and byways of Southern California by slightly less than reputable young men, first appeared in the late 1930s and early 1940s. Primarily designed for drag racing on public roads, the early rodder's primary goal was to make the engine more powerful while reducing the weight of the body, a combination that guaranteed more speed. With the end of World War II and the return to America of thousands of young men, every one of whom wanted

his own set of wheels, the hot rod evolved into something for show as much as go. Street rods with pounds of extra chrome and incredibly elaborate paint schemes were sensory magnets designed to attract the thing, to paraphrase Rogers & Hammerstein, like which there isn't any other: dames. Hot rods offered a new sense of freedom to America's young men.

Cars in general and hot rods in particular could show off teenagers' ability to build and often race their one-of-a-kind creations, or just show off, period. No parents hovering around asking dumb questions, just a

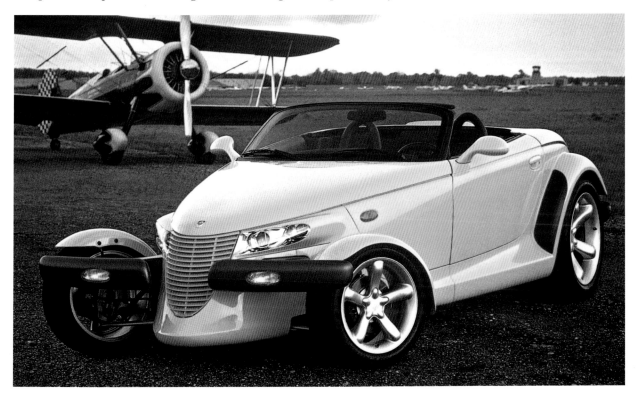

1999 Plymouth Prowler.

boy and his car. With a car he could also attract a girl. If he got lucky, he might spend some time with her in the back seat (assuming he had a back seat). In short, the car was the perfect accoutrement for the typical teenager who had plenty of time, very little money, and a thing about appearance.

Today, some fifty years down the highway, the hot rod is back in all its glory, and for much the same reasons. Now sought after by wealthy collectors, they're even being shown at places such as the prestigious Pebble Beach Concours d'Elegance.

When Chrysler introduced the Plymouth Prowler, their reincarnation of the hot roadster, as a show car a few years ago, it didn't take them long

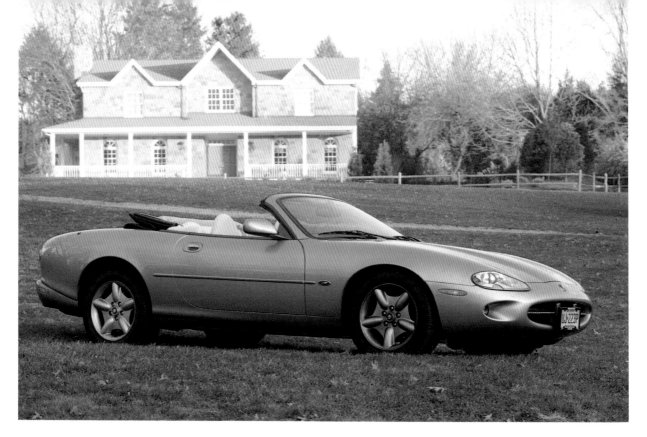

Male or female, young or old, the owner of this 1997 Jaguar XK-8 is going to get noticed.

to realize they had a winner on their hands. It probably wasn't the teenagers gawking at the car that prompted the decision to put it into production, it was the kids' dads. The guys with the forty big ones to spend: Guys who want to be noticed. As *Car and Driver* magazine pointed out, "Unless you can find an Oscar Mayer Wienermobile chauffeured by a circus clown, you can't buy more attention."

For those in the throes of a midlife crisis, the convertible provides a perfect object for typical middle-aged fantasies, both sexual and aggressive. Its appearance alone provides a means for expressing rebellion. A chance to show off. An arena for one-upmanship. A way to attract a younger woman and a way to get her to a motel once you pick her up. Buying a Plymouth Prowler or BMW Z-3 is the perfect pastime for the typical midlife crisis male who has lots of time, lots of money, and a thing about appearance.

Of course not everyone agrees that a hot convertible is guaranteed to send the sort of message its owner has in mind. Psychologist Dr. Joyce Brothers for one believes that while the middle-aged male in the new ragtop, "thinks that he is saying 'I'm still very interesting, look at me sexually,' what he is really saying is, 'Well maybe I am not at the crest, I may be starting on the down swing.' "

So much for the middle-aged man, but what about his female counterpart? Is she consigned forever to sit behind the wheel of some nonde-

LAST SUNSET—THE DEATH OF TOM MIX

Tom Mix. A name that was once instantly recognized by people the world over: Spanish-American War hero; major motion picture star; rodeo and circus impresario; sportsman and a lover of fast cars.

Born in 1880, he was the most popular western star in movie history. On the screen his preferred mode of transportation was astride Tony, "The Wonder Horse." Off camera he favored custom built Cadillacs, Duesenbergs, and Cords. By the end of the 1930s, his movie career at an end, he parlayed his huge popularity into well-paying personal appearance tours here and abroad.

In 1940, while touring the southwestern United States, Mix left Tuscon, Arizona, on a Saturday afternoon headed north for an engagement in Phoenix. Wearing his trademark ten-gallon Stetson, diamond-studded belt buckle, and custom boots, he put the pedal to the metal of his supercharged, custom Cord 812, intending to make quick work of the 100-mile trip. Sometime later, after rounding a curve at high speed, he unexpectedly encountered a highway work crew. Quickly swerving into a detour, he lost control of the car as it careened down a dry wash then up the other side where it flipped over, pinning him underneath. The workmen were able to quickly right the car, but Mix was already dead, his neck broken by a suitcase that had torn loose and hit him from behind.

He was mourned by millions. A memorial depicting a riderless horse was erected at the crash site. "In memory of Tom Mix, whose spirit left his body on this spot and whose characterizations and portrayals in life served to better fix memories of the old west in the minds of living men."

Mix's explanation for the enduring success of his film persona could have been a blueprint for *Route 66*, or any number of contemporary films or television shows:

> *I ride into a place owning my own horse, saddle, and bridle. It isn't my quarrel, but I get into trouble doing the right thing for somebody else. When it's all ironed out, I never get any money reward.*

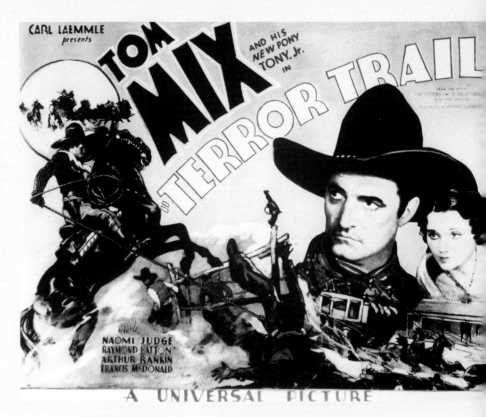

Above: Tom Mix in *Terror Trail* (Universal Pictures, 1933).

Below: Mix's custom supercharged Cord 812 phaeton.

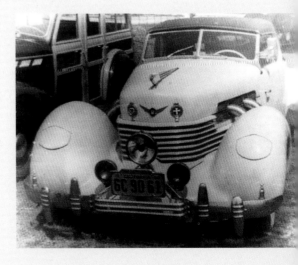

57

script minivan, or will she too take to the road, top lowered, in search of
a boy-toy to play with?

Automotive columnist and author Lesley Hazleton, who has driven
and written about everything from a two-cylinder Deux Chevaux to a 420
hp, 190 mph, Lamborghini Countach, says flat out what she thinks in her
book *Confessions of a Fast Woman*:

> *We are misled in our thinking about cars by the fact that even now,
> after a hundred years of automobility, women still give over so
> much of the involvement in them to men. Although women now buy
> close to half the cars in the United States, women engineers are a
> small minority, women mechanics are relatively rare, and there
> are only a handful of women race drivers. But there exists a mul-
> titude of women who love their cars with a passion as great as
> that of any male teenager and his first clunker. After all, if a fast
> car can make a man feel more powerful, think how much more it
> can do for a woman.*

In *Everything Women Always Wanted to Know about Cars* she inter-
viewed women from all walks of life and all areas of the country on the
subject:

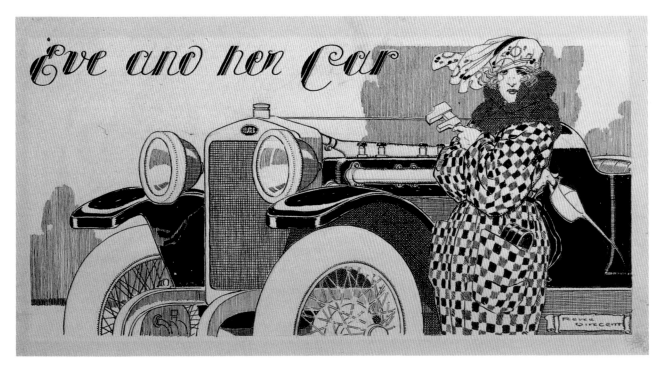

Eve and her Car

"It took me until my mid-forties to realize I was a top-down kind of girl. Then I saw a little silver Miata and was absolutely smitten. I said to my husband, 'We really have to talk,' and he was very relieved when he realized it was just a car."

"I bought a '66 Mustang convertible brand new and I still have it to this day, and if you ever want a car to attract men, I guarantee you it is not a new sports car, but a '66 Mustang."

Everyone deserves a midlife crisis, according to Hazleton:

I think the mid-life crisis has been much maligned. In fact, midlife is the best time to have a crisis. It's when you have the money to go for the most elegant solution, which is a roadster. And the experience to drive it so that the solution won't kill you. Women and the mid-life crisis? Of course! Neither crises nor roadsters are gender-specific. What better way to celebrate the empty nest than to take your top down.

Rene Vincent, *Eve and Her Car,* 1920. (From the collection of Terry and Eva Herndon)

WOMEN IN CARS
by Martha McFerren (1992)

More women have done this
than you'd imagine.

You're out there driving
back from Grand Saline or wherever
they made something happen
that particular Saturday.
Actually, *he's* doing the driving
and you're just sitting there
twiddling with the radio.

It's night on a two-lane blacktop.
There's nobody in the state,
except the stuff that's
been run over, and
already your date is yelling,
"Let's play like we're
in England," and scooting over
to the opposite lane
every ten minutes or so,
and you are so awfully bored.

So you start taking off
your clothes, starting with
your shoes, then your earrings,
then your shirt and bra.
Getting out of your
blue jeans isn't easy.
You have to hoist your rump
and buck forward with your knees
like you're doing the limbo,
but let's admit it,
climbing out of jeans in cars
is a native art.

When I was driving
with a boy named Frank Fallis,
I even whipped off my phoney
ponytail and threw it
in the back seat, and he screamed,
"GAAAAAA," and skidded off
the road. And then he said,
really sarcastic, "You got
anything *else* unnatural?"

You can ride hours like that
with the wind and the bugs
blowing all over you,
and some Wilson Pickett.
If you go through a place
like Scofield or La Tuna
you don't even have to duck.
They're all in bed
with their shades down,
dreaming about rain.

There's simply nothing out there.
Some people say Texans
think more about wheels than sex,
but you have to understand
the distances involved.

Opposite: In charge, atop a 1968 Oldsmobile 442.

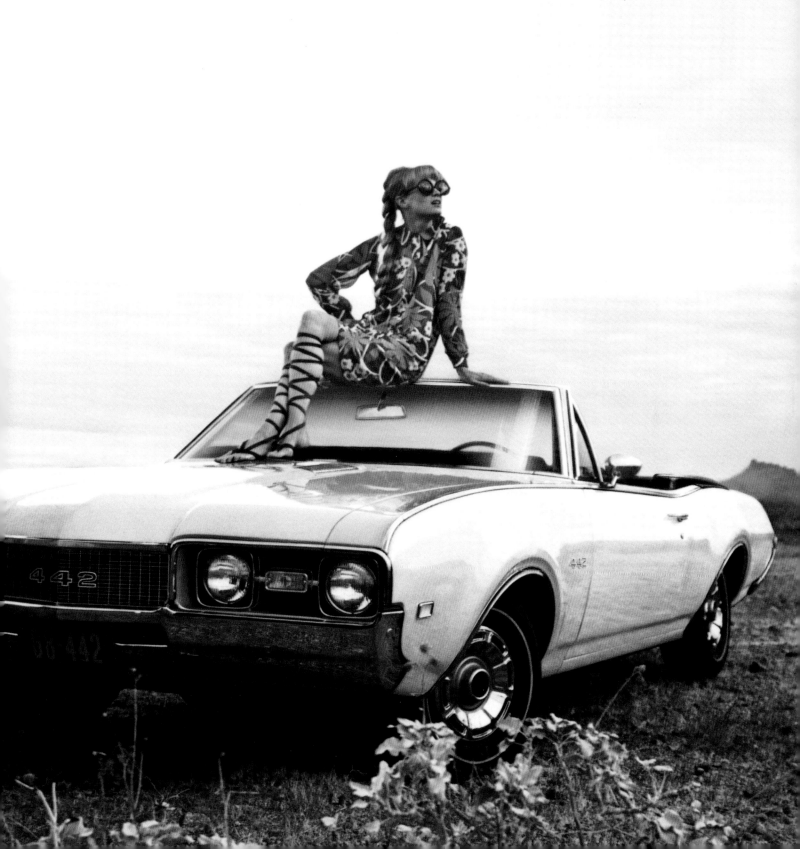

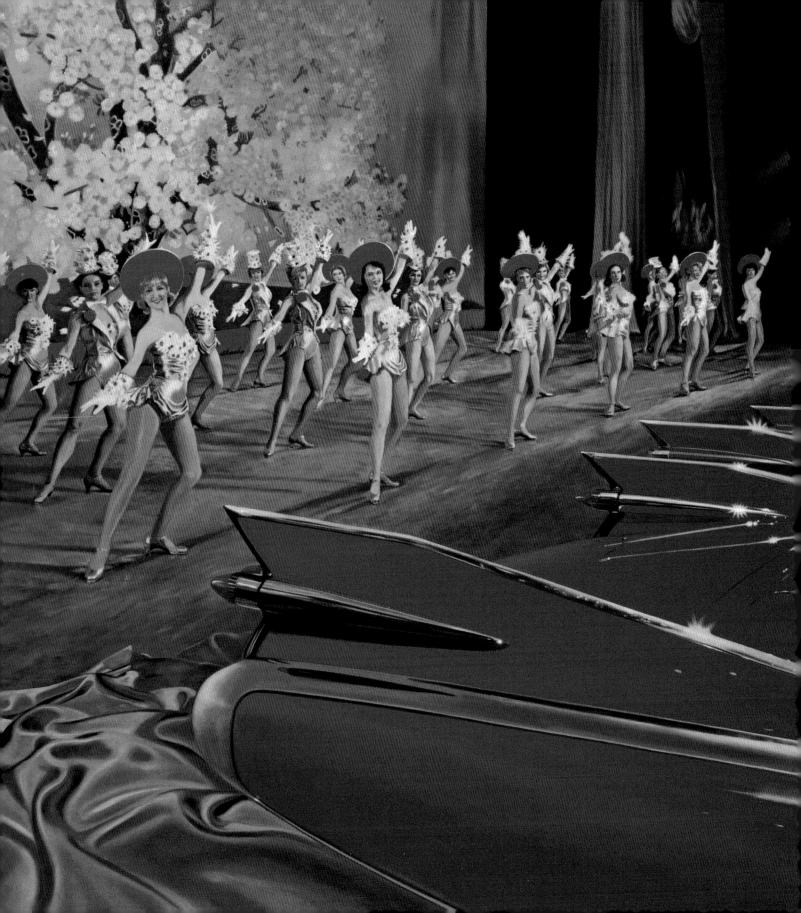

The Convertible As Muse

3

Extolling the joys of the ragtop life

Even in the early days of the silent film, directors realized that planes, trains, horses, and automobiles were great subjects. But cars were not only more controllable than the other choices, they also permitted the actors to interact with each other in a variety of dramatic or comedic circumstances. The convertible always has afforded a much better look at the stars one paid to see than does a sedan with its confining, light-absorbing roof.

The list of films featuring convertibles is long, including everything from the Keystone Kops, Laurel and Hardy, the great 1930s madcap comedies, and the coming of (teen) age hot rod flicks of the 1950s, to *The Absent Minded Professor*, the Beach Blanket Bimbos in the 1960s and, of course, the classic west coast car culture epic, *American Graffiti* in 1973. There's something about all that open air that encourages the sort of behavior frowned upon by the AAA.

The Corvette that Jack Nicholson is piloting so adroitly in *Terms of Endearment* (1983) is but one example of the countless times that Chevrolet's sporty two-seater has been the object of cinematic attention. In some instances, such as *Stingray* and *Corvette Summer*, the car itself got top billing. Corvettes may be cool, but for those who like 'em hot nothing beats the cinematic sizzle of a great big, mile-long Cadillac Eldorado de Ville with humongous tail fins.

The bigger the fins the better, and from 1948 to 1959 Cadillac was the undisputed ruler in the kingdom of the tail fin. Originally inspired by the tail treatment on the World War II Lockheed P-38 fighter airplane, the fins seemingly took on a life of their own, growing like some crazed metallic life-form on steroids until they reached their ultimate destiny in 1959. As Christopher Finch points out in his book *Highways to Heaven*, certain

"Included is a set of scarves by Givenchy."

Above: Drawing by Bernard Schoenbaum; © The New Yorker Magazine, Inc.

Opposite: Nicola Wood, *Rockettes*, detail, 1992.

FROM *CRASH*
by J. G. Ballard (1973)

When I collected the American convertible, the rental company salesman remarked, "We had a job cleaning it up, Mr. Ballard. One of your TV companies was using it—camera clamps on the roof, all over the doors and bonnet."

The notion that the car was still being used as part of an imaginary event occurred to me as I drove away from the garage in Shepperton. Like the other cars I had hired, this one was covered with scratches and heelmarks, cigarette burns and scuffings, translated through the glamorous dimension of Detroit design. On the pink vinyl seat was a deep tear large enough to take a flagstaff or, conceivably, a penis. Presumably these marks had been made within the context of imaginary dramas devised by the various companies using the car, by actors playing the roles of detectives and petty criminals, secret agents and absconding heiresses. The worn steering wheel carried in its cleats the grease of hundreds of hands held there in the positions dictated by the film director and the cameraman.

64

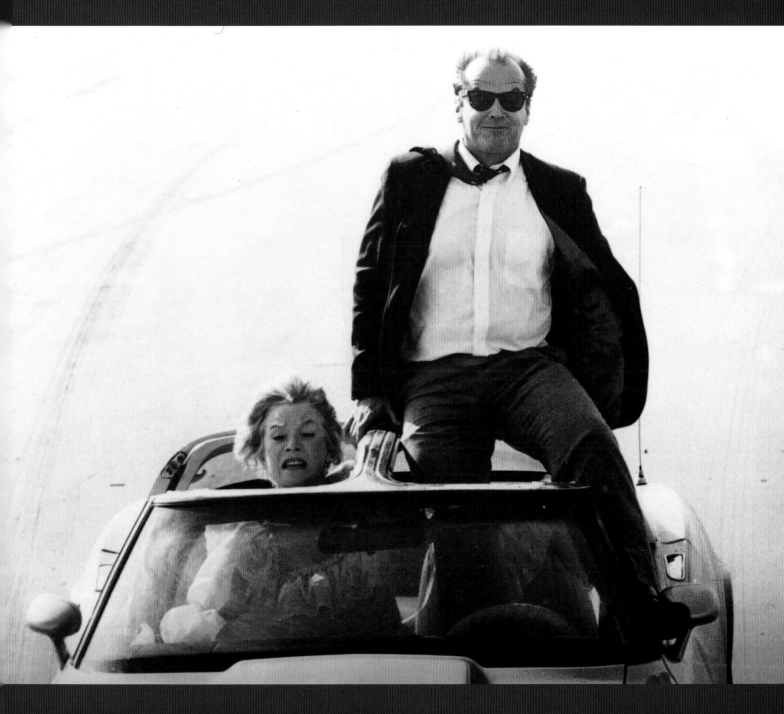

Jack Nicholson and Shirley MacLaine in *Terms of Endearment* (Paramount Pictures, 1983).

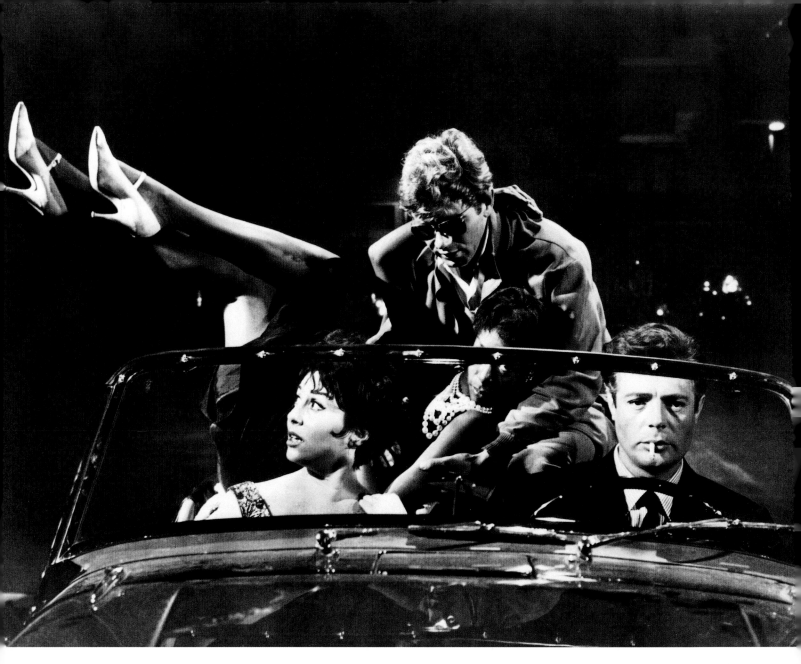

An unhappy looking Marcello Mastroianni and friends fill up his Triumph TR-3 in *La Dolce Vita* (Astor Pictures, 1959).

1950s Cadillacs came with some non-standard dealer options in the libido department:

> The late fifties Cadillac was perhaps the ultimate in fetishized sex. Advertisements for the Cadillac were aimed at the country-club set and Fifth Avenue crowd (or those who aspired to such status), but in reality the Cadillac was perceived just as readily as the car owned by sex symbols like Elvis Presley, who bought them by the dozen, and Jayne Mansfield. Jayne Mansfield not only owned

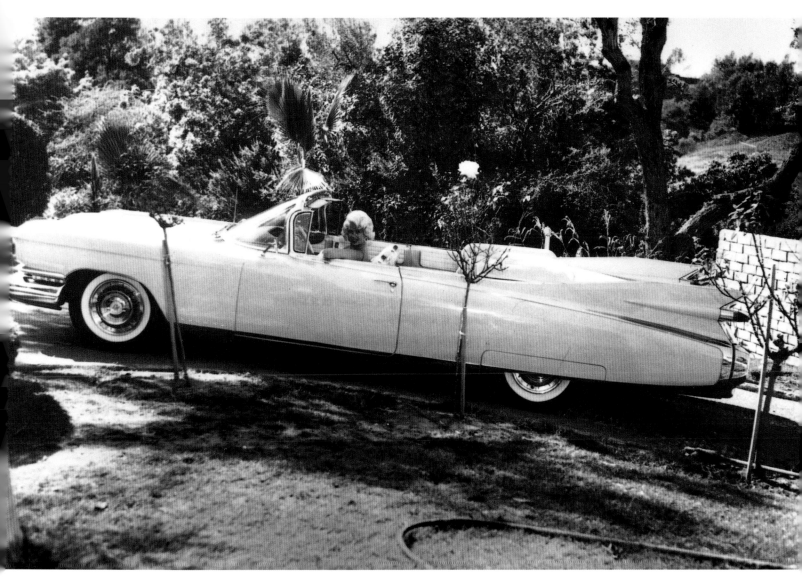

Cadillacs (and died in one), she was a Cadillac incarnate. Or was it the other way around? In any case, these two assemblages of manifold fetishes had a good deal in common: larger-than-life presence, chutzpah, self-proclaimed glamour, and unapologetically baroque bodywork. Mansfield's masses of peroxide hair could even be compared to the Caddie's acres of chrome. Some would argue that Mansfield lacked the Cadillac's class, but it is open to debate as to whether the Cadillac at this time possessed class in any traditional sense of the word.

Jayne Mansfield and her 1959 Cadillac Eldorado. (It had to be pink.)

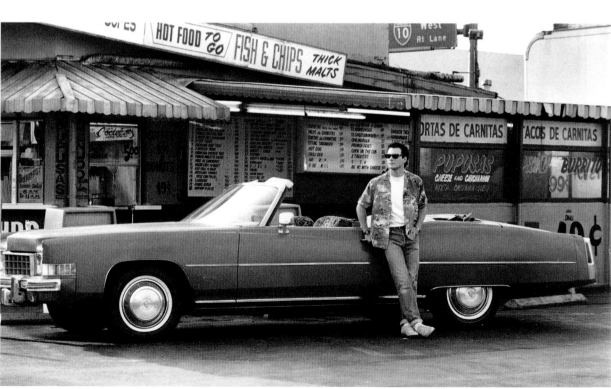

Immortalized in movies such as *Girl in a Cadillac, Blue de Ville, Coupe de Ville, Cadillac Man, Cadillac Ranch,* and *Pink Cadillac,* Cadillacs also have inspired writers, authors, photographers, and songwriters, such as Bruce Springsteen.

Well, now you might think I'm foolin',
for the foolish things I do.
You may wonder how come I love you,
when you get on my nerves like you do.
Well, baby, you know you bug me,
there ain't no secret 'bout that.
Well, honey it ain't your money
'cause baby, I got plenty of that.
I love you for your

CHORUS:
Pink Cadillac,
crushed red velvet seats,
Riding in the back,
oozing down the streets,
Waving to the girls,
Feeling out of sight,
Spending all my money on a Saturday night.
Honey I just wonder what you do there
in the back of your pink Cadillac,
pink Cadillac.

Heard any other good Cadillac songs lately? If not, you might want to give a listen to "Big Black Cadillac Blues" (Lightnin' Hopkins), "Brand New Cadillac" (The Clash), "Cadillac Walk" (Willie Deville), "Cadillac Brougham" (The Beach Boys), "Cadillac Assembly Line" (Albert King), "Cadillac Avenue" (Don Henry), "Geronimo's Cadillac" (Michael Murphy), "Guitars and Cadillacs" (Dwight Yoakam), "Long White Cadillac" (The Blasters), "Ray's Dad's Cadillac" (Joni Mitchell), "Rusty's Cadillac" (Da Yoopers), "They've Downsized My Cadillac" (Dick Siegel), "Twin Cadillac Valentine" (Screaming Blue Messiahs), and "Cadillac Ranch" (Chris LeDoux).

When Aretha Franklin sang about riding down the freeway of love in a pink Cadillac there could be no doubt that it was a 1959 Eldorado de Ville she was crusin' in; ditto Southern Pacific's "Reno Bound" from the film *Pink Cadillac.*

Above: Pink Cadillac, one-eighteenth scale model by Maisto.

Below: A music box that plays, you guessed it, "Pink Cadillac."

Opposite: In the thirty-one years between the release of *Hud* (Paramount Pictures, 1962) and *True Romance* (Morgan Creek Productions, 1993), the tail fins may have disappeared, but Paul Newman and Christian Slater are proof that the Eldorado convertible remains a cinematic conveyance of choice for the Hollywood hunk.

Above: Henri de Toulouse-Lautrec, *L'Automobiliste*, 1898. One of seven remaining examples of the original twenty. (The Museum of Modern Art. Gift of Abby Aldrich Rockefeller. Photograph © 1998, The Museum of Modern Art, New York)

Opposite: Jean Jacquelin, Delage poster, 1939. Jacquelin cleverly showed the car's country of origin with three flowers: cornflower, daisy, and poppy. (l'art et l'automobile Gallery, New York)

We got the radio up
We got the top rolled down
We got the cleanest Eldorado around
Pearl pink Cadillac
Long and shiny Cadillac
Open ragtop Cadillac
Reno bound.

While motion pictures, popular songs, and the convertible seemingly were made for one another, depiction of the ragtop is by no means exclusive to the performing arts. The first internal combustion engine had barely coughed into life when, in 1898, Henri de Toulouse-Lautrec immortalized the new invention in his lithograph, *The Automobilist*.

While it was unusual for an artist of Lautrec's stature to choose the automobile as a subject, automobiles in general and convertibles in particular featured prominently in the many automotive posters that became popular in the early years of the century and remain popular to this day. Among the more famous names that have contributed to the art of the poster are Rene Magritte, Giorgio De Chirico, and LeRoy Neiman. The roster of major artists who have chosen to work with automotive themes would fill a page, ranging as it does from Lautrec to Pierre Bonnard, Henri Matisse, John Sloan, Marcel Duchamp, Salvador Dali, Edward Hopper, Grant Wood, Roy Lichtenstein, and Andy Warhol.

The number of collectors of automotive art and automobilia has grown spectacularly over the past ten years, giving rise to an entire genre of artists who have carved out niches for themselves in specialized areas. Although the majority would be classed as photo realists, their work covers the entire art spectrum including collage, stained glass, and sculpture.

Unlike other forms of artistic expression, photography has pretty much grown up with the automobile. Its earliest exponent was Jacques-Henri Lartigue. Born in France in 1894, Lartigue loved cars and began taking photographs of them at the age of seven. Along with Robert Demachy, Eugene Atget, Alfred Stieglitz,

DELAGE

J.JACQUELIN.39

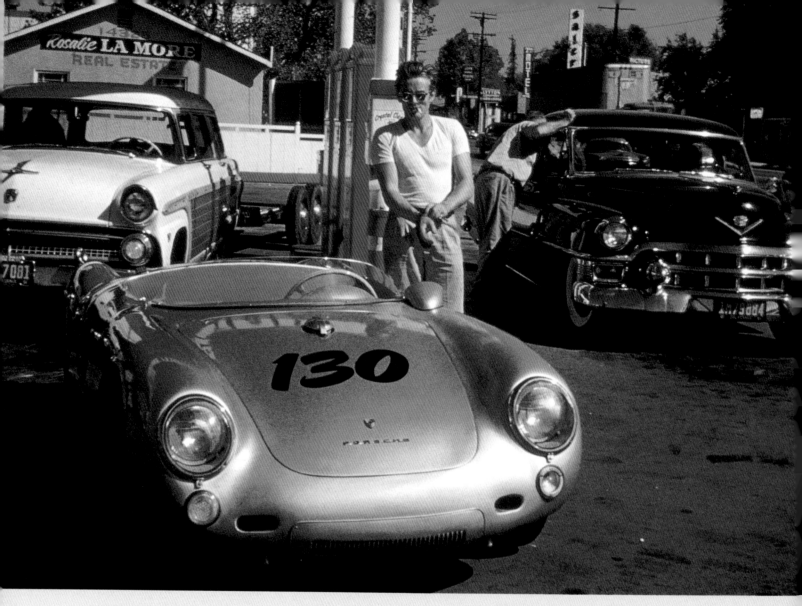

A final stop for gas in Los Angeles.

JAMES DEAN, DONALD TURNUPSEED, AND THE "LITTLE BASTARD"
A True Car Tale

James Byron Dean was born on Februrary 8, 1931 in Marion, Indiana. Over the next twenty-four years he moved rapidly from troubled adolescent to troubled young adult to troubled movie star to troubled teen idol. He died on September 30, 1955, on a highway near Cholame, California, and became a legend.

Dean had just completed his third (and final) film, *Giant*, in which he co-starred with Elizabeth Taylor and Rock Hudson, and was eager to pursue his new avocation: racing driver. Between the completion of his prior

72

film, *Rebel without a Cause,* and the start of principal photography on *Giant,* Dean had entered his Porsche 356 in three West Coast races where he acquitted himself quite well against some of the best drivers of the time. Although very quick, the 356 actually was just a street car set up for racing. What Dean wanted was an all-out racing machine. Just before *Giant* finished shooting, he got one, a new Porsche 550 Spyder.

Dean took his new acquisition to the shop of famed custom car king, George Barris, for some additional paint work. Barris, who had met Dean during the filming of *Rebel without a Cause,* felt that there was something strange about the car, "a feeling, bad vibrations, an aura; call it what you will . . . it made me uneasy," he said.

Dean was all worked up about how he was going to race it that weekend, but I couldn't get enthusiastic about the car. He dropped it off on Tuesday morning and came back for it that afternoon. I had crazy feelings about wanting to stop him as I watched him drive away from my shop. But I didn't. At that time I was a non-believer in ESP or psychic phenomena, so I didn't want to sound like a "kook." It wasn't until after the accident and a whole string of tragedies that followed—all related to that car—that I began to accept the psychic sciences. Everything that car has touched has turned to tragedy. It's baffled me for years. I've never been able to come up with logical or rational answers to the questions. The only answer seems to be that the car was cursed.

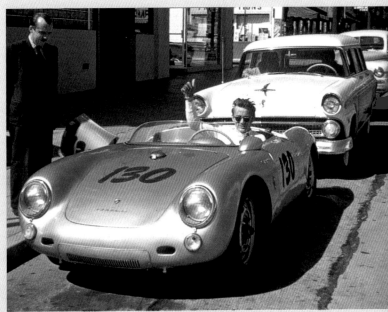

Setting off for Salinas. September 30, 1955.

The day after he finished filming, Dean and his mechanic, Rolf Wütherich, set off in the Porsche, now sporting the words "Little Bastard," (one of Dean's nicknames) on the car's rear engine cover. They were headed for a weekend of racing in Salinas, California. At about 5:45 P.M., Dean was going west on a long stretch of straight road near the town of Cholame. A 1950 Ford Custom Two-Door Coupe driven by a twenty-three-year-old college student named Donald Turnupseed was driving east on the same road. As the two cars neared one another, Turnupseed started to make a left turn onto a side road, cutting directly into the path of the speeding Porsche. Dean lifted his foot off the gas pedal and spoke what were to be his final words to Wütherich. "That guy up there's gotta stop. He'll see us."

But, in the twilight, Turnupseed didn't see the low-slung Porsche.

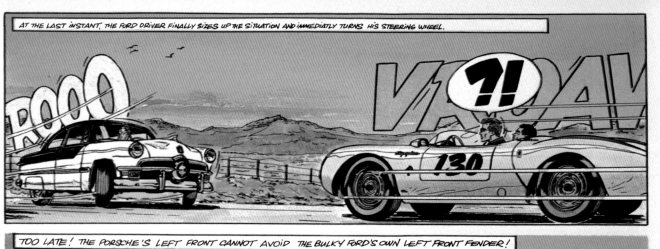

AT THE LAST INSTANT, THE FORD DRIVER FINALLY SIZES UP THE SITUATION AND IMMEDIATLY TURNS HIS STEERING WHEEL.

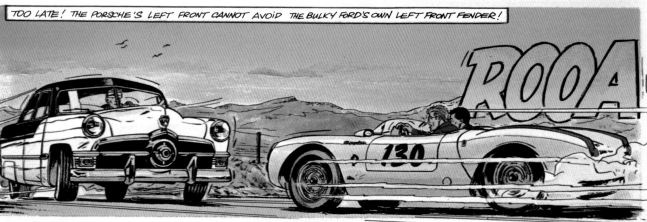

TOO LATE! THE PORSCHE'S LEFT FRONT CANNOT AVOID THE BULKY FORD'S OWN LEFT FRONT FENDER!

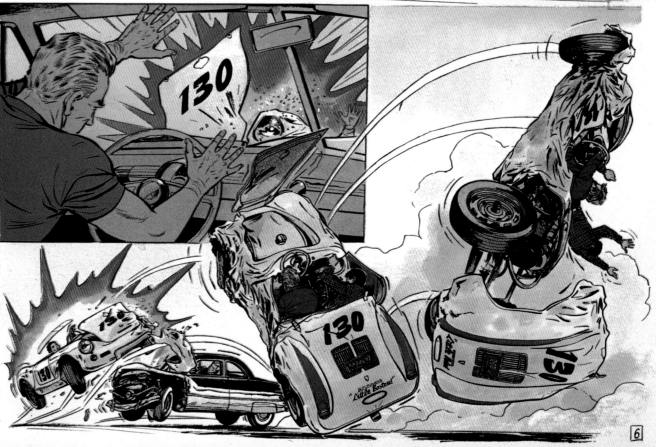

Then, suddenly, he realized the other car was there. He slammed on the brakes, changed his mind and floored the gas pedal trying to complete the turn before the Porsche got there, only to inexplicably hit the brakes one final time. Jimmy Dean was about to become a legend.

If Dean's Porsche 550 was indeed "cursed," then it would seem to have achieved its purpose. Now twisted and torn almost beyond recognition, it was a prime candidate for the crusher. Barris purchased the wreck for $2,500, figuring to make a profit by salvaging the engine and whatever else was usable. What he didn't figure on was that by salvaging the car he was also salvaging the curse, and the car, living up to its evil reputation, wasted no time in striking again. As it was being unloaded at Barris's shop it fell on a mechanic, breaking both of his legs. The engine was bought by an amateur driver who crashed and was killed the first time he raced it. The drive train was put into another racer, and it flipped over in its first race. The tires went onto a third car; within a week both front tires had simultaneously blown, hurling the car off the road. As for the rest of the car, the California Highway Patrol made it the centerpiece of a travelling safety campaign aimed at teenagers. On one of the stops it fell off of its display stand and broke a boy's hip. Then, the driver of the truck carrying the display was killed.

Over the next few years the car was involved in at least three other incidents resulting in property damage. Finally, in 1960, the Florida Highway Patrol, who had finished using the car in their own safe driving campaign, put it aboard a train for shipment back to Barris. It never arrived, and it has not been seen or heard of to this day.

A final footnote to the story involves Dean's mechanic, Rolf Wütherich, who survived the crash that killed Dean with a broken jaw and a crushed left leg. Convicted of killing his wife in 1968, he ultimately returned to Germany where he was killed in a car crash in 1981. Was the car really cursed? No one can say for certain but, should you happen to come across the missing wreck, head in the other direction, just to be on the safe side.

Opposite: This rendering of the accident by French artist Jean Graton is about as close as we are likely to get to what really happened. It is from the book *James Dean, The Untold Story of a Passion for Speed* by Graton and Philippe Defechereux, the definitive work on Dean's short racing career.

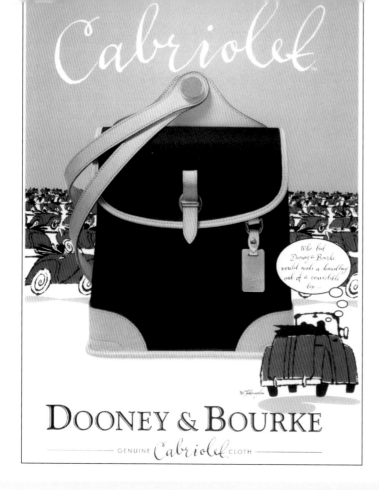

Cabriolet

DOONEY & BOURKE
— GENUINE *Cabriolet* CLOTH —

Dorothea Lange, Walker Evans, and Robert Frank, he recognized the important role the automobile played in an ever more complex modern society. As with fine art, automotive photography has produced a number of modern masters, many of whom, such as Roy Query, Jay Hirsch, and Martyn Goddard, choose to focus on the beauty of yesterday's great classic convertibles.

Convertibles also have featured prominently in advertising campaigns that have nothing to do with the automotive industry. The image of beautiful, carefree, (usually) young people enjoying the top-down life as an adjunct to whatever's being sold undoubtedly moves product or they'd be driving something else. One company, Dooney & Bourke, made a point of selling high-end handbags constructed of "genuine cabriolet cloth."

Dooney & Bourke ad for Cabriolet cloth handbags. Peter Dooney, an acknowledged car nut, searched for years to find cloth that had the perfect balance of texture, weight, and durability only to find it where he least expected to: in his garage.

FROM
THE GREAT GATSBY
By F. Scott Fitzgerald (1925)

At nine o'clock, one morning late in July, Gatsby's gorgeous car lurched up the rocky drive to my door and gave out a burst of melody from its three-noted horn. It was the first time he had called on me, though I had gone to two of his parties, mounted in his hydroplane, and, at his urgent invitation, made frequent use of his beach.

"Good morning, old sport. You're having lunch with me today and I thought we'd ride up together."

He was balancing himself on the dashboard of his car with that resourcefulness of movement that is so peculiarly American—that comes, I suppose, with the absence of lifting work in youth and, even more, with the formless grace of our nervous, sporadic games. This quality was continually breaking through his punctilious manner in the shape of restlessness. He was never quite still; there was always a tapping foot somewhere or the impatient opening and closing of a hand.

He saw me looking with admiration at his car.

"It's pretty, isn't it old sport?" He jumped off to give me a better view. "Haven't you ever seen it before?"

I'd seen it. Everybody had seen it. It was a rich cream color, bright with nickel, swollen here and there in its monstrous length with triumphant hat-boxes and supper-boxes and tool-boxes, and terraced with a labyrinth of windshields that mirrored a dozen suns. Sitting down behind many layers of glass in a sort of green leather conservatory, we started to town.

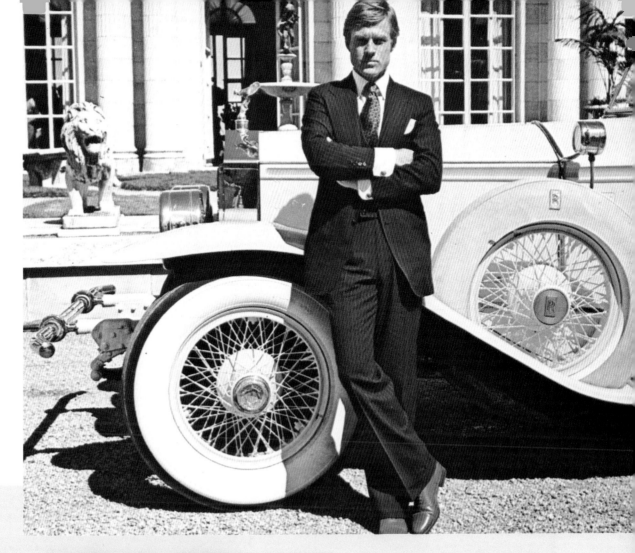

Above: Robert Redford, as Jay Gatsby, leans
against the magnificent Rolls-Royce convert-
ible in *The Great Gatsby* (Paramount
Pictures, 1974).

Left: F. Scott Fitzgerald, Zelda, and Scottie
taking the air in a Renault somewhere in
Italy during the mid-1920s.

Get a Load of That

They float, they fly & other oddities

Place the shifter in neutral. Turn key to "Acc." Move control switch to "retract." Deck lock motor is now actuated. Two flexible driveshafts release the forward corners of the decklid. That motion actuates two more switches allowing current to flow to the deck open power relay which actuates the deck motor. Two screw-type actuating jacks raise the decklid to a near vertical position. This mechanical motion actuates another switch which closes a set of contacts actuating the tray motor and extending the rear shelf until it is parallel to the decklid, tripping another switch to shut itself off. This action triggers the roof unlock cycle allowing current to flow through the position "A" switch to the roof unlock power relay actuating the roof front unlock motor and the two rear lock motors which drive the poser locks. The locks unscrew the roof from its mountings activating more switches which in turn activate the roof motor. After reaching a height of four inches the roof lock motors stop and retraction begins. The ten-inch forward flipper section folds down using a mechanical linkage and its own motor and worm drive. With the roof now inside the rear storage compartment a set of contacts closes allowing current to flow to the deck lock power relay actuating the decklid and deck lock motors, closing and locking the decklid. Once fully closed and locked, the cycle indicator switch goes out indicating completion of the retract cycle. The actuation switch may now be released.

Instructions for astronauts on a shuttle mission? No, just the mechanics of putting down the retractable hardtop on a 1957 Ford Skyliner. In their print advertising Ford explained it all in seventy-five words or less, beginning with, "Here's how the world's only Hide-Away

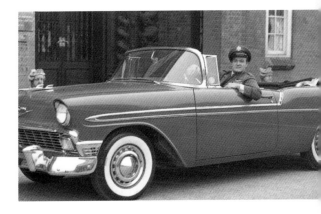

Above: Bob Hope, seen here in a Chevrolet Bel Air, had his own take on the Skyliner: "Have you seen Ford's new convertible hardtop? You can fold the whole car up and put it in your glove compartment."

Opposite: The 1957 Hop Rod as described by the man on the UPI desk: *"Rolling merrily along, Bryan goes for a spin on the highway in his 'convertible.' The craft has become a familiar sight to residents of the area, and the driver and passenger of the passing car don't even give him a second glance. Powered by the same pusher propeller that drives it through the air, the car can reach 60 miles an hour on the road."*

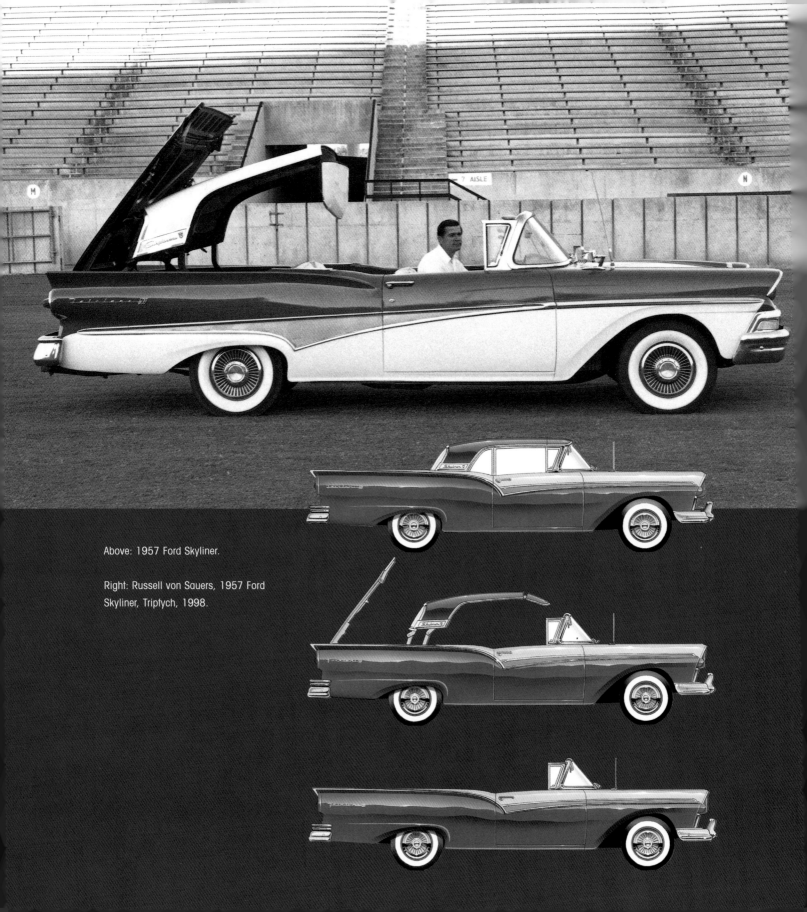

Above: 1957 Ford Skyliner.

Right: Russell von Sauers, 1957 Ford
Skyliner, Triptych, 1998.

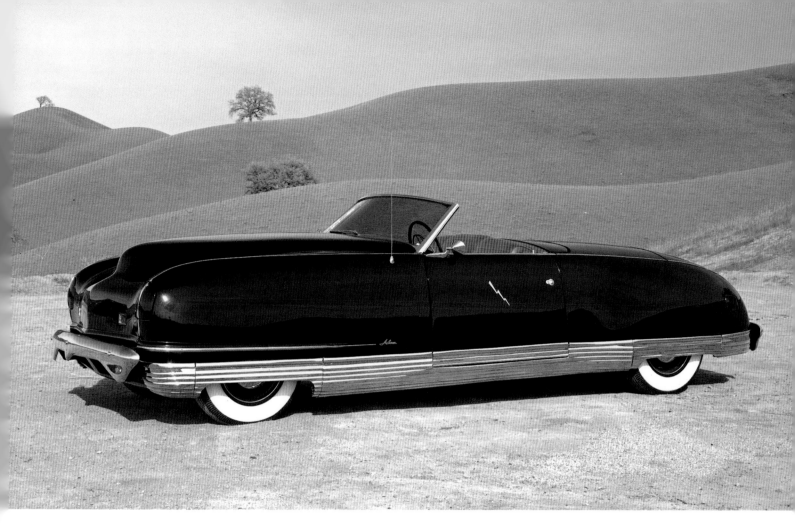

The LeBaron-bodied 1941 Chrysler
Thunderbolt retractable hardtop.

Hardtop operates at the touch of a button." But to the guy who designed the complicated mechanism, it was "a plumber's nightmare."

Much the way pens that write underwater, multi-function knives, and Russian Army night-vision glasses hold a certain fascination for the male of the species, the retractable hardtop convertible tempts automobile designers. The idea itself is not new. Peugeot made a successful version, the Decapotable Electrique, in 1934. In 1941, the Chrysler Thunderbolt retractable toured the auto show circuit, but because of their complexity and cost, they soon disappeared from the marketplace.

However, like the proverbial cat, the retractable hardtop convertible keeps coming back. One of Chrysler's new breed of retro-style show cars, the Phaeton, is a retractable hardtop. Mercedes has put one into production, the 1998 SLK 230, but to date, Ford has been the only manufacturer to spend the requisite millions to put a retractable on the market in great numbers and keep it there for any length of time. From its official introduction on April 14, 1957, when President Eisenhower took delivery of the first one, to the end of its production run in 1959, Ford made 48,388

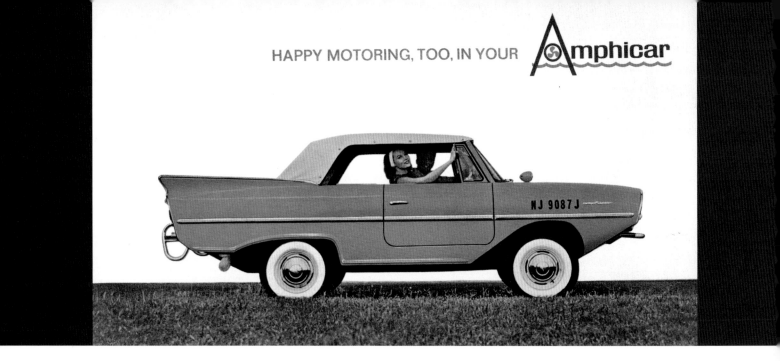

The Amphicar sales brochure highlights the vehicle's dual functions. "Drive down to the shore . . . in . . . and cruise away."

Skyliners. Prized by collectors, they now cost far above their original $3,137.69.

The mechanisms of the retractable hardtop were pretty complicated, but they were simple compared to the complexities of building a car that could double as a boat or even as an airplane.

In 1805, American inventor Oliver Evans manufactured something called the Amphibious Digger. A huge, twenty-ton dredging vehicle, it was capable of functioning on land or water and reputedly had a top speed of 4 mph. A hundred years later, the great French writer Jules Verne postulated an even more amazing machine in his book, *Master of the World.* This vehicle, called the Epouvante, was equal parts automobile, submarine, and airplane. Verne, of course, didn't have to worry about making the damn thing.

Hans Trippel may not be as well known as Jules Verne, but he did manage to design and build a vehicle in which any average Joe or Joanne could drive to the local bait shop, and after stocking up on worms, head for the nearest lake, drive in, and do some fishing. He called it the Amphicar.

About 4,500 Amphicars were manufactured between 1960 and 1967. Approximately half of them still exist. Powered (underpowered) by a 43 hp Triumph Herald engine, the Amphicar is not much for speed on land or

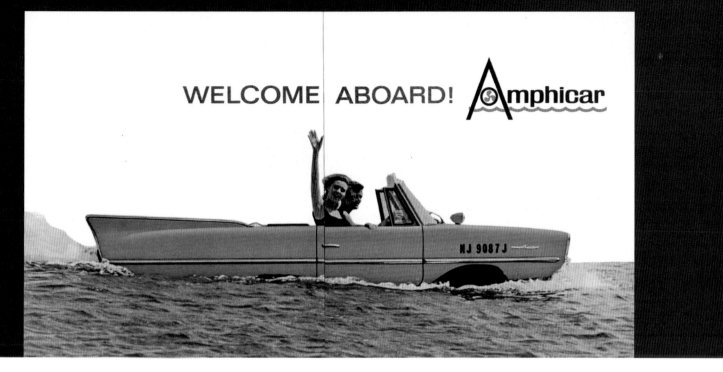

WELCOME ABOARD! **Amphicar**

sea. A pair of props, mounted below the rear bumper, supply aquatic propulsion, while steering is accomplished exactly as it is on land, via the front wheels.

Not everyone was in agreement as to just how well it accomplished its dual missions. In the opinion of *Car and Driver* magazine, "It's not a good enough car for the average driver, yet neither is it a good enough boat for the serious boating enthusiast." The folks at *Car Life* were a good deal more enthusiastic. "Fifteen years in the making, it is the ultimate in play-time vehicles." They did voice one note of caution however, recommending that "passengers do not try to open the door and get out while on water." What was probably the ultimate Amphicar experience happened on September 16, 1965, when two of the amphibians managed to cross the English Channel from Dover to Calais.

Now desired collectibles, Amphicars have brought in more than twenty grand at auction. Among the more notable original Amphicar owners was President Lyndon Johnson, who used it on the lake at his Texas ranch. Current collectors include Ted Danson and Dan Aykroyd, who has two. The vehicle has also become quite popular among airline pilots and the computer gurus of Silicon Valley.

If you're thinking of buying, the man to talk to is Hugh Gordon of Santa Fe Springs, California, who rebuilds them using the inventory he

"Amphicar's purrr on the highway becomes a br-rrr in the water with a flick of the wrist."

purchased from the original manufacturer. But even this unabashed Amphicar enthusiast, who says they're "the greatest things for meeting girls," has moments of doubt. "You never get used to the feeling when you drive down the boat ramp and the water rolls over the windshield and you are convinced you are going to sink."

If driving an Amphicar into the bounding main doesn't sound excit-

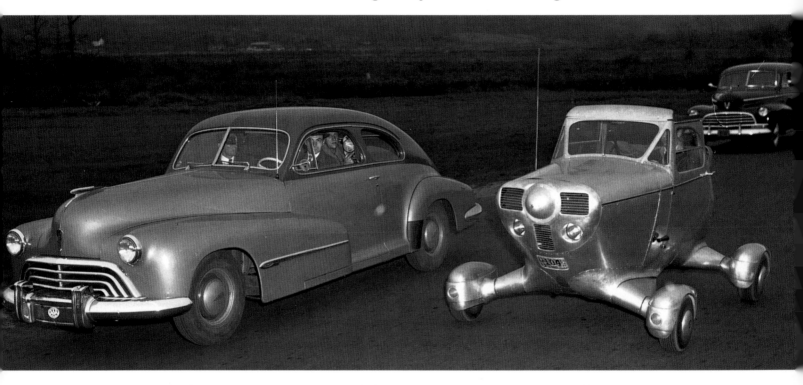

The 1946 Airphibian takes to the highway, accompanied by the ever present paparazzi. Rumor has it that for a mere $500,000 or so, the sons of Robert E. Fulton, Jr., the Airphibian's inventor, will build you a new one.

ing enough for you, then how about a little cloud hopping in your merry aerocar? Flying cars are certainly among the most imaginative of road vehicles that convert in order to allow their occupants to get out into the open air. If fact, it would be hard to find another car that could take people into the air quite the way these did.

The idea of cars that also can fly is not a recent one. Sir George Cayley designed and built a device he called the "coachman carrier" in 1808. Essentially a glider with a removable road carriage suspended underneath, the device actually became airborne during tests in Yorkshire, England.

To date there have been about a half-dozen serious attempts to design and/or manufacture a successful aerocar. One, the 1947 ConvAIRCAR, made use of a lightweight fiberglass car body suspended from a removable wing/engine assembly. It was promoted as, "An auto-

mobile as roomy as a Cadillac, yet weighs only 725 pounds . . . a top speed of 80 mph . . . accelerates better than the average car and climbs the steepest hills, yet gets 60 miles per gallon. The flight section is a completely operable airplane in itself except for a seat and landing gear." The ConvAIRCAR had a flying speed of 128 mph, a range of 400 miles, and a ceiling altitude of 11,500 feet. What it didn't have was buyers.

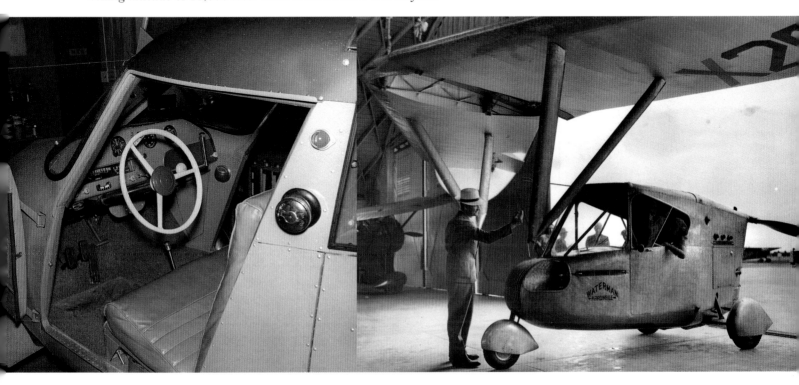

The most successful attempt was the Taylor/Aerocar. Designed and built by Moulton B. Taylor, the Aerocar went from conceptual drawings in 1947 to Civil Aviation Administration certification in 1956. Between then and 1967, seven Aerocars were built, driven, and flown successfully. Powered by a four-cylinder opposed Lycoming aircraft engine, it could cruise at 140 mph with a 500-mile range. On the road it got 15 mpg with a top speed of 60 mph. Like the vehicles that had preceded it, the Aerocar was ultimately doomed to failure. Taylor could not find a corporate backer that shared his vision, a point he made in a 1983 interview in *Sport Aviation* magazine:

> *Flying automobiles have been created and demonstrated which already have all the capabilities of conventional "land-locked" automobiles, yet can fly with the performance and capabilities of*

Left: The less than luxurious interior of the 1957 Aerocar I.

Right: In 1937 a flying car inventor named Waldo Waterman almost succeeded in convincing Studebaker to sell his Arrowbile in its dealers' showrooms. A demonstration flight was arranged at the National Studebaker Dealer's Association convention. Bad move. The Arrowbile crashed, and although five more prototypes were built, the company never got off the ground.

Above: The car in the film *Chitty Chitty Bang Bang* (United Artists, 1968) was based on an actual vehicle. Built in 1920 by one Count Zoborowski, it was powered by a German Maybach Zeppelin engine. This version, as driven by Dick van Dyke, was prone to flights of special effects fancy.

FROM *CHITTY-CHITTY-BANG-BANG* by Ian Fleming (1964)

A kind of soft humming noise began. It seemed to come from all over the car—from the front axle and from the back axle, and from underneath the hood. And then the most extraordinary transmogrifications (which is just a long word for "changes") began to occur. The big front mudguards swiveled outwards so that they stuck out like wings sharply swept back, and the smaller back mudguards did the same (it was lucky the road was wide, and there was single-lane traffic, or a neighboring car or a telegraph pole might have been sliced in half by the sharp green wings!). The wings locked into position with a click and, at the same time, though the family couldn't see it from behind, the big radiator grill slid open like a sliding door, and the big propeller of the fan belt, together with the flywheel underneath that runs the gas pump and the electric generator, slowly slid forward until they were sticking right out in front of the hood of the car.

And then, on the dashboard, beside another little lever, a green light started to blink and this light said, "PULL DOWN," and Commander Pott, rather nervously, but this time obediently, reached over and gingerly pulled the lever very, very slowly down.

And then, in heaven's name, what do you think happened?

Yes, you're right, absolutely right. The wings slowly tilted and, as Commander Pott, at last realizing what CHITTY-CHITTY-BANG-BANG was up to, pressed down on the accelerator pedal, the big green car, which was now what I might call an aerocar, tilted up her shining green-and-silver nose and took off!

Opposite: Fred MacMurray and canine companion doing the flying thing in *Son of Flubber* (Walt Disney Productions, 1962).

today's conventional aircraft. Further development of these vehicles is no longer a matter of technologies, but merely depend on the availability of capital.

Not surprisingly, the most successful flying cars to date have been those produced in Hollywood. To see Fred MacMurray piloting his Model-T in *The Absent Minded Professor* and *Son of Flubber*, Dick van Dyke at

Above right: Albert Guibarra's Hippomobile was featured in Harrod Blank's book and film, *Wild Wheels*. (Photo: Harrod Blank)

the wheel of *Chitty Chitty Bang Bang*, or the flying DeLorean in *Back to the Future* is to glimpse a bit of what those who pioneered the flying automobile were dreaming of.

Those who dream of cars that float and cars that fly are not the only visionaries in the convertible world. In Albert Guibarra's dream, cars become animals. Guibarra is the designer and owner of the Hippomobile. Based on a 1971 Ford Mustang convertible, the Hippomobile is 600 pounds of brass and copper sculpted to resemble that staple of old Tarzan movies, the hippopotamus. The "car" features a wagging tail, a sound system that plays a variety of hippopotamus tunes, including "I Want a Hippopotamus for Christmas," and the unique ability to leave a cute (?) puddle of water in its wake at the push of a button on the dashboard.

Below right: From the 1960s television show *Batman* (Twentieth Century Fox), the Dynamic Duo head for their next adventure. The Batmobile's cockpit featured Batphones, a Batscope, and everything else needed by your typical caped crime fighter.

Still, if one car can hold the title of "ultimate convertible," it has to be the black beauty driven by Bruce Wayne, the car known to generations of American kids as the Batmobile. Why, in a world of cabriolets, drop-heads, retractables, amphibians, and aerocars, does this car deserve to stand alone? The Batmobile is the only convertible in the world that also requires the driver to convert to Batman before driving off in it.

Appropriately enough, the Batmobile began its life as an auto-show dream car, the Lincoln Futura. Built by Italian coachbuilder Ghia in 1955, the car worked the show circuit and co-starred with Glenn Ford and Debbie Reynolds in the 1959 film *It Started with a Kiss*. When the producers of the upcoming Batman TV series asked George Barris, the Futura's current owner, to build the Batmobile, he used the Futura as the starting point. The end result was the most famous dream car in history.

The Batmobile in repose (*Batman,* Twentieth Century Fox).

"GENTLEMEN (AND LADIES) START YOUR CONVERTIBLES"

Above right: The field takes the green at Bowman Gray Stadium in 1957.

Below right: Louise Smith and Ethel Flock, two of the best in the early 1950s.

Below: Richard Petty, the "King" of NASCAR, and his Oldsmobile convertible at Daytona in 1959.

The obvious dangers inherent in a sedan without a solid roof over the head of its occupants would seem to preclude putting them on a track and racing them, but that's exactly what NASCAR did in the late 1950s. "The deal was," recalls Richard Petty, "they had two circuits, one for hardtops, another for convertibles . . . a lot of times we raced separately, but in some races they were mixed and we raced against each other."

Those early days on the stock car circuit offered the fans something else that was about as unusual as racing convertibles: women race drivers. The few of them out there were quite capable of mixing it up with the men, and from all accounts, giving as good as they got. One of the best was Ethel Flock, sister to the famous Flock brothers, Fonty, Bob, and two-time National Champion, Tim:

The best race I ever did at Daytona on the beach track, there was Bob, Fonty, and Tim and myself and I had nobody to sponsor me, but I had a Cadillac convertible, and I told Charlie Mobley, my first husband, I said, "I'm goina go in that race." He said, "What you goina drive?" I said, "I'm goina drive my Cadillac."

So she did, and finished fourth, managing to beat her brothers.

Although it was great for the fans to be able to look down into the cars and see the drivers at work, drivers found the decision to end the topless circuit in 1960 something of a relief.

For NASCAR the convertible has been consigned to history, part of a colorful past when men, and women, could go to the track, "run what they brung," and maybe even take home a few dollars. Dangerous enough in the 1950s, they are all but unthinkable today when speeds of 200 mph are commonplace.

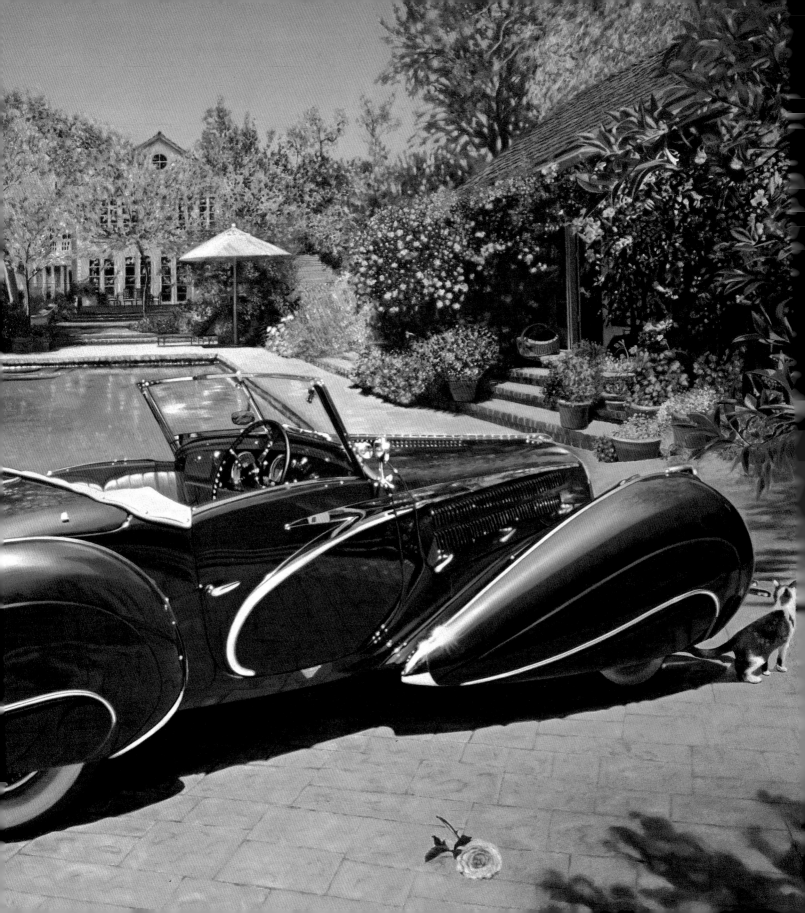

5

Convertible Dreams

Inventive, individual, idealized, idiosyncratic & positively incomparable

Convertibles have been photographed, painted, written and sung about for more than a century. But while the ragtop inspires some creators to feature them in their chosen artistic discipline, there is another, no less committed group, for whom the convertible is itself the medium.

To attend a great Concours d'Elegance (a French term for an exhibition of elegant automobiles) is to see what the combination of large sums of money and intense passion for great cars can accomplish. For the owner of a classic car that has been painstakingly restored to (better than) original condition, there is no greater reward than to place "best of show" in one of the premier concours events such as Greenwich, Connecticut, Meadow Brook, Michigan, Pebble Beach, California, or one of the international Louis Vuitton Classics. In order to win best of show, a car must not only be perfect in every way, but also be better in some intangible way than the other perfect cars it is competing against. Michael Lamm addressed this issue in a *New York Times* story on the Pebble Beach event:

> *The columnist Ellen Goodman once wrote that some contestants in the Miss America Pageant owed their beauty not to their Maker, but to their re-maker: Miss Florida's nose came courtesy of her surgeon. So did Miss Alaska's. Miss Oregon's breasts came from silicone. Similarly, the stunning automobiles that win top honors at high-profile collector shows—like the Pebble Beach Concours d'Elegance—owe their beauty not so much to the companies that manufactured them, but to the well-heeled collectors who have had the cars essentially remanufactured. Most of the cars have*

Above: *Kitty Litter*, Dennis Corrigan, 1990.

Opposite: Figoni et Falaschi–bodied 1937 Delahaye 135M Roadster. A stunning example of the coachbuilder's art captured on canvas by Nicola Wood, detail, 1995.

Above: Like Ralph Lauren and many others, artist Tom Hale fell under the spell of the seductive SSK. In his notes to himself regarding his painting for the poster, he wrote: "Car should look approachable, as though you are walking up to it—intimate and private, as though it's yours."

Right: One of a number of detailed models of the SSK; this, from German maker CMC, was chosen "Model of the Year" in 1995.

been restored not to their original factory condition, but to a level of perfection considerably above that. They are far better than they were when new.

For those who own and restore these magnificent machines to this ultimate condition, the car itself has become a work of art, or, in the words of Arthur Drexler, a former curator of the Museum of Modern Art, "rolling sculpture."

One of the most beautiful of all these show-stopping classic cars is a 1930 Mercedes-Benz SSK owned by world famous designer Ralph Lauren. Lauren, whose extensive collection features some of the world's most beautiful automobiles, has long had a passion for automotive objects of desire:

You never forget your first car. Mine was a cream-colored '61 Morgan convertible with a leather strap across the hood and wood along the running boards. When I took it out for a drive with the top down I thought I was in heaven.

There are, of course, other ways of making the car itself the work of art. In the era of the great classics, most high-end automobile manufacturers would sell their cars complete and ready to run, but without a body. The buyer would then take the chassis to one of the many available coachbuilding firms, who would design and construct a one-of-a-kind body for it. And, while there have been many famous and talented coachbuilders plying their trade during the past century, there are two names which stand out above all others: Figoni et Falaschi.

THE COUNT, THE DESIGNER, AND THE SSK
A True Car Tale

The story of the 1930 Mercedes Super Sport Kurz, or SSK, actually began in 1923, when German engineering genius Dr. Ferdinand Porsche (also responsible for the Volkswagen Beetle) designed the first of the approximately 375 Mercedes "S" class cars that would be built over the next ten years. Between 1923 and 1928 the car evolved from a 4.0-liter-six-cylinder into a 6.2-liter, and finally a supercharged 7.1-liter Super Sports that produced 300 hp. In 1928 the car was offered with the chassis shortened from 134 inches to 116, making it a Super Sport Kurz ("short").

The SSK: front view, cockpit, and exhaust pipes.

This particular car, chassis No. 36038, one of about 40 SSKs built, was completed in the summer of 1930 and shipped to Japan where it languished for two years without finding a buyer. From Japan it went to Milan, Italy, where it was finally sold to Count Felice Trossi. Trossi, a wealthy aristocrat, loved fast cars, airplanes, and boats, racing each of them quite successfully on the continent. He was also an inventor, ornithologist, architect, and engineer, who constructed his own Grand Prix car in 1935. If that didn't fill up his résumé, he could also lay legitimate claim to the title of automobile stylist. The design for the beautiful and totally atypical SSK coachwork, with its flowing aero-influenced fenders, pointed tail, V-windshield, and cut-down cockpit sides came directly from the count's pen.

Rather than use one of the many famous coachbuilders of the day, Trossi had the chassis shipped to England where a craftsman named

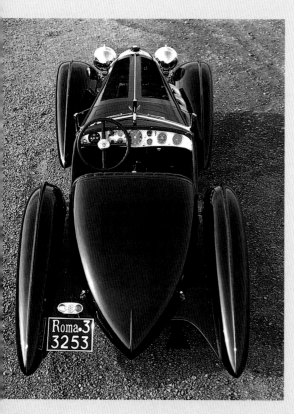

The Trossi SSK's distinctive pointed tail.

Willie White hand-hammered the aluminum body over an oak frame. The end result is a car that has been described as not only the most beautiful Mercedes-Benz ever built but, the "most spectacular *car* in the world."

Based on the descriptions of those who have driven the car it goes as fast as it looks like it could; its 431 cubic inch 300 hp supercharged engine could pull the 4,200 pound machine from 0 to 60 in nine seconds with a top speed of about 120 mph. In the words of one test driver, "It's not sound without fury . . . the engine sounding like a demented Gatling gun as I lift off the throttle at speed." Performance of that caliber in a machine this old is nothing short of astonishing. As might be expected, it is also not an easy car to maintain. The mechanical workings of the supercharger alone take up over fourteen pages in the car's instruction manual. As for the factory recommended service schedule, the requirements for the 18,000 mile checkup begin with the instruction: Disassemble the complete car.

As a final word of caution the owner's manual also forbids parking the car under a linden tree.

Between the time he purchased the car and his untimely death from cancer at the age of forty-one in 1949, Count Trossi sold the car not once, but three times. In each instance, unable to bear the thought of his "love" in the hands of another, he bought it back. To keep the car from sharing the fate of many other pre-war classics, which were destroyed during World War II, Trossi had the SSK shipped to his estate in Argentina, where it remained for the duration.

After Trossi's death, the car passed through the hands of five different owners before being purchased in 1988 by famed fashion designer and classic car collector Ralph Lauren. Early in 1992, Lauren put the car into the hands of restoration expert Paul Russell in Essex, Massachusetts. Over the next eighteen months, Russell and his staff stripped down the car and did a ground-up 5,000 hour rebuild. To appreciate the amount of work that goes into a restoration of this type, one need look no further than the SSK's missing door latches. After conducting a worldwide search, they were traced by Russell to a small garage in Germany where he successfully bartered for their return, along with the original oil pan, which he discovered while nosing around the place. With the restoration completed, the newly finished car was shipped almost immediately to the Pebble Beach Concours where it took best of show honors for its proud owner.

Almost as if it were a living creature that is not content simply to exist as one of the most beautiful cars on the planet, the Trossi SSK has managed to find other ways to stand out in a field full of stand-outs. The car

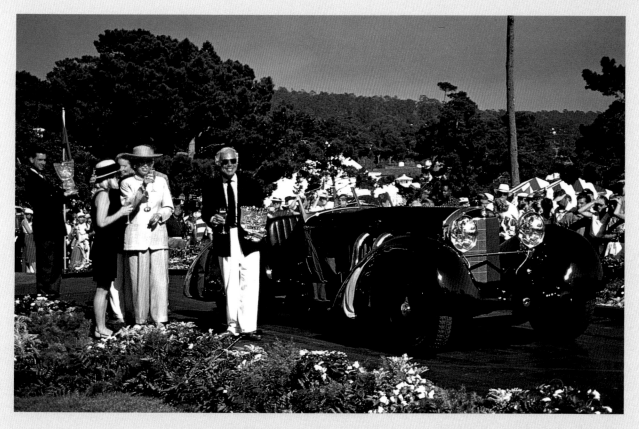

has become a favorite subject of automotive writers, photographers, painters, and model makers the world over.

Ralph Lauren accepts the trophy for Best of Show at Pebble Beach, 1993.

Of all the artists who have been inspired to render their interpretations of the SSK, none could have approached the task with more thoroughness than Tom Hale. Commissioned in December 1993 to depict the car for use on a poster for another prestigious concours, this one at Meadow Brook Hall in Rochester, Michigan, Hale spent countless hours doing a series of preparatory sketches and paintings that culminated in a work of art worthy of its subject. The final painting was completed on December 28, 1994, with the finished poster following two months later.

And how does the present owner view this and the other cars in which he's invested so much time, money, and love? "I don't buy cars to win contests; I buy them to drive. There's nothing like waking up on a nice sunny day, putting on a hat and goggles, folding down the top of a convertible, and putting it through a few paces on a country road."

The SSK, which also has been featured in Lauren's evocative fashion ads, is rumored to be an upcoming guest on *Oprah*.

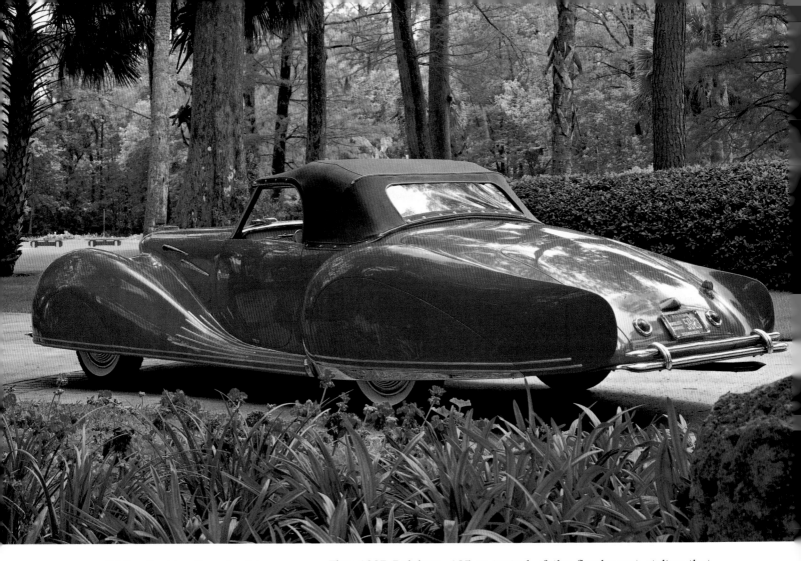

Delahaye Roadster with coachwork by Figoni et Falaschi.

This 1937 Delahaye 135 is typical of the flamboyant styling that caused Jaguar founder Sir William Lyons to categorize their work as "positively indecent," while another amusing stiff upper lip referred to them as "Phony and Flashy." Fortunately, such views were decidedly in the minority. For twenty years Joseph Figoni and Ovidio Falaschi worked their magic to produce more than eleven hundred coachbuilt bodies, primarily, but not exclusively, on French chassis. They were particularly known for large, flowing, all-enveloping fenders (or "enveloppantes" as Falaschi called them) that seemed to grow out of the bodywork the way wings swept out of aircraft fuselages. The fenders were formed from as many as forty-eight hand-hammered pieces of steel that were butt-welded together, section by section, until they gave the appearance of having been sculpted. As the coachbuilders of choice for most Delahaye and Delage customers, Figoni et Falaschi probably inspired Peter Ustinov's sly remark: "One drives, of course, an Alfa Romeo; one is driven in a Rolls-

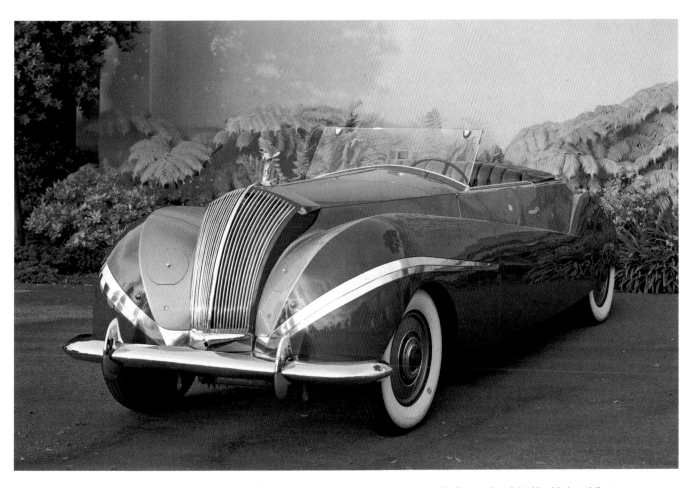

Royce; but one gives only a Delage to one's favorite mistress."

According to Falaschi, "We really were veritable couturiers of automotive coachwork, dressing and undressing a chassis one, two, three times and even more before arriving at the definitive line that we wanted to give to a specific chassis-coachwork ensemble."

While the custom coachbuilder has all but disappeared, there are other artists who make the car itself an integral part of the creative process, a blank canvas of endless possibilities. These artists work with the actual car itself, either reshaping it as sculpture like Arman, César, and John Chamberlain, or using its surface for their canvas, as Andy Warhol, Roy Lichtenstein, Alexander Calder, and others did for BMW. But none has done this on so grand a scale as Japanese painter Hiro Yamagata, whose show, *Earthly Paradise*, was presented at the Los Angeles Municipal Art Gallery in the fall of 1994.

As the coachwork by Henri Labourdette on this 1939 Rolls-Royce Phantom III shows, Figoni et Falaschi had no monopoly on sensuous automotive designs.

FROM *HIRO YAMAGATA,* *EARTHLY PARADISE*

Introduction by Allen Ginsberg (1994)

Hiro Yamagata's taken the most brilliant of all cars—in his view—the long outmoded Mercedes Benz Cabriolet 220—an aristocrat of capitalist cars, luxurious toy of the tasteful racy rich—to rescue it from oblivion, alchemize the wreckage to exemplary totemhood. Cannibalizing the bodies of dozens or hundreds of such cars, he's reversed Time's ravage of these wearouts. Not quite mass produced, not quite singular & unreplica'd, with old handcraft style & artisan comeliness, sleek modish dated chic & charm—Yamagata's resurrected this mid-century's last grasp of "innocent" mechanical beauty.

With an eccentric idea, the use of the "ultimate" car for floral arrangements or sky & ocean waves usually reserved for Japanese fans, screens or exquisite nightclub wallpaper, the artist's imagination's run wild on hood & fender canvas. Paint the universe itself! Paint the high class villainous machine with 1960's flowerpowered lilies orchids daisies, Fijian blossoms, porcelain bugs & butterflies, graffitian tattoos, funky hallucinatory flowers on the carapace of a finetuned German machine. Disney meets Hitler, Mickey Mouse wraps up the Nazis, (i.e., not to be chauvinistic about German politics) Free imagination meets Naïve Industrialization. In any case Japanese and German modern technologic "Idealism" is subjected to the extremest sophisticated whims of a highly competent individual artist with the Herculean means to undertake symbolic cleaning of the liquid-looking horseless carriage's Augean Stables.

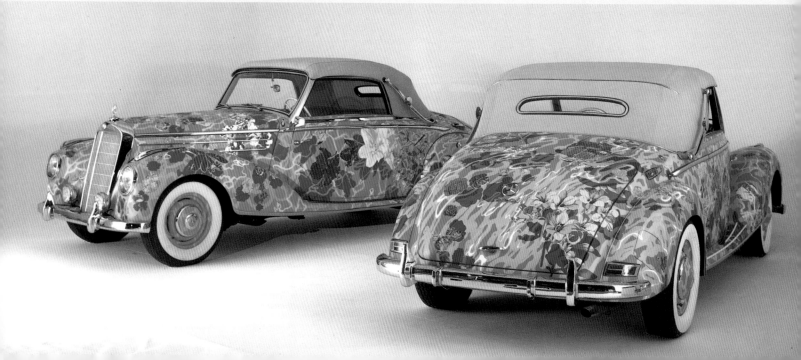

It is almost impossible to imagine the amount of time, money, and creative energy expended to accomplish this most beautiful and unusual work of art. To begin with, there are a finite number of Mercedes-Benz 220 A Cabriolets in existence. Built from 1951 to 1955, its production run totaled only 1,278. By the time Yamagata began his search for those that still survived, they had been dispersed to the four corners of the earth. And, to make things even more complex, Yamagata wanted only perfect examples with which to fulfill his vision. This meant that each car had to undergo a six-month ground-up restoration to concours standards. This involved removing the bodies from the frames, stripping away each of the car's components, and rebuilding them, literally, from the ground up.

The restored cars, painted uniformly with a white matte acrylic finish, arrived at the studio to complete their transformation from Benz to butterfly. Each "canvas" was then worked on by the artist and his team of assistants to realize Yamagata's dream of the ultimate Los Angeles cruising machine. Cabriolets covered with tropical flowers sit next to others with images of beaches, palm trees, sea, and sky. A vision of the automotive world like no other: an earthly paradise.

The convertible has been inspiring artists and craftsmen working in nearly every medium for more than a century. As each succeeding generation of ragtop lovers brings its own sensibilities and prejudices to the question of what the convertible is all about, we can only expect more of the same.

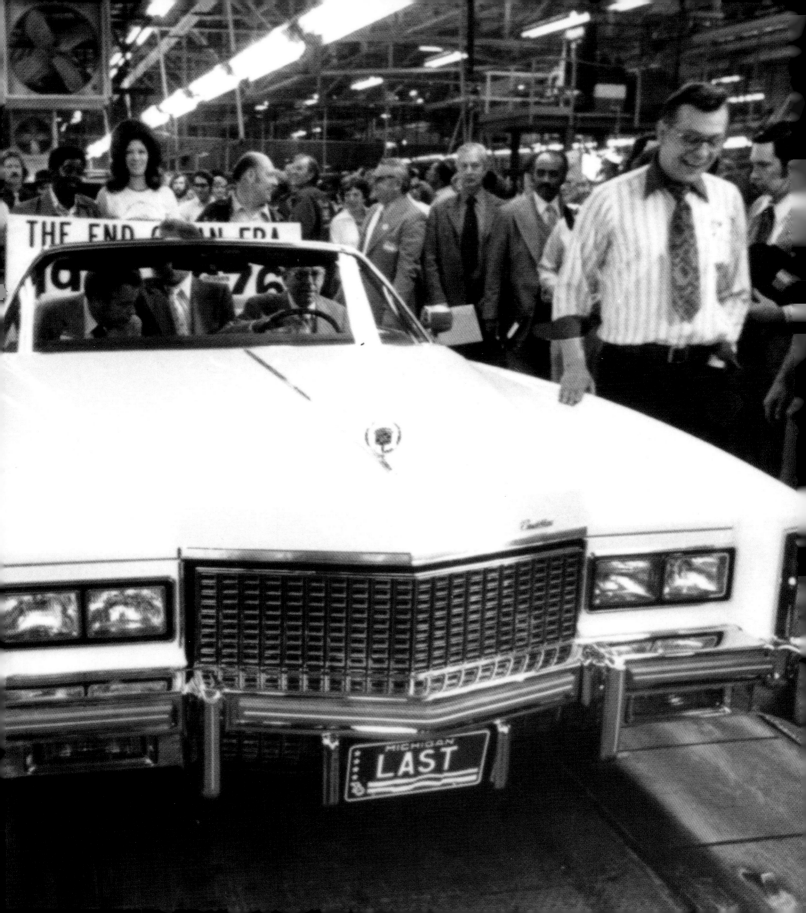

Fall and Rise 6

1969–1999

By the end of 1969, the major automobile manufacturers knew that the convertible was in trouble. There was no single reason for their rapid decline but rather a series of seemingly unrelated events that added up to disaster. Take air conditioning for example. During the 1960s, cars equipped with air conditioning went from occupying 11 percent of the market to 55 percent. With air conditioning you didn't need to put the top down to stay cool, and you avoided the ever increasing varieties of odoriferous pollution hovering over all but the most remote byways. Music or, more precisely, the ability to hear it was another factor. Aftermarket car stereo systems were becoming more and more popular with young potential convertible buyers. But what good was spending a small fortune on a great car stereo when you couldn't hear it worth a damn with the top down, or even with it up, given the lack of exterior sound-deadening insulation on all but the most expensive models? One could also factor in the fuel crisis, inflation, new safety concerns that brought the threat of draconian government regulations, and the rise in street crime, particularly automobile break-ins. All it takes is a sharp knife to let yourself into someone else's convertible. Sales were falling off so rapidly that by the end of 1970 the total number of ragtops sold would drop below 92,000. This was only five years after sales had topped half a million.

Another influence, and one that the corporate pundits in Detroit totally misread, was the increasing popularity of the small imported car. They were well made, inexpensive to own and operate, and they offered something that no domestic manufacturer offered as optional equipment: political correctness. The late 1960s and early 1970s were a time of great social and political upheaval in America. A large segment of those who were under thirty, and might have been expected to buy a domestic convertible, made the decision not to support American big business dur-

Above: Drawing by Frank Cotham; © The New Yorker Magazine, Inc.

Opposite: The "last" Cadillac convertible.

103

Above: The 1966 Volkswagen convertible.
The bug goes topless.

ing the Vietnam War. Particularly when television commercials for new model cars were interspersed between graphic footage of demonstrations, assassinations, and, of course, the daily body count from Vietnam. Concerns about the environment were also coming to the fore. American cars were big gas-guzzlers emitting unacceptably high concentrations of pollutants into the atmosphere. The smaller foreign convertibles also had something else going for them: price. A 1970 Cadillac DeVille convertible went for about $7,000, while the Volkswagen Beetle version was some $4,500 cheaper. Whatever the reasons, and there were many, the big American convertible was dying, down to 27,955 units sold in 1974.

Among the missing in the dealer's showrooms that year was the Ford Mustang. Once the top-selling ponycar, the Mustang convertible ceased to be at the end of the 1973 model year. Ford, shrewdly announcing in advance that 1973 would be the end of the line, managed to sell 12,000 that year, a 50 percent increase over the previous three years.

Ford's chief stylist at the time offered up a somewhat strange epitaph for this, and all of Detroit's vanishing ragtops:

©87 Nicola Wood

The 1965 Mustang made its debut at the New York World's Fair on April 17, 1964. In its first year on the market Ford sold 680,989, an all-time record for first-year sales. In March of 1966 they topped the million mark. Pretty impressive for a car that had been dubbed "the poor man's Thunderbird." Watercolor by Nicola Wood.

One of the two hundred Cadillac Bicentennial convertibles.

The sun burned the hell out of me in the summer, and in the winter I kept the top down till water froze in my hair. And my wife always complained that it ruined her hair. So why did I have it? It was a great car for watching polo.

By the end of 1975, all American manufacturers had stopped making ragtops save one: the lone hold-out, Cadillac, soon announced that 1976 would see the final Eldorado convertible roll off of the assembly line. They also announced that they were doubling the production run to 14,000 in order to make sure that everybody who so desired would have an opportunity to buy one. What they didn't specify was the actual price. The sticker price was about $12,000. But what dealer worthy of the name was going to sell "the last convertible" at the sticker price?

"We expect to sell every one," said GM general manager Edward Kennard. "I've already received letters from people saying they want to buy the last one. Maybe we should make the last 2,000 the same, call it the 'Finale' and get another two or three hundred for it." General Motors created a "Last of the Convertibles" committee whose members decided that of the 14,000 last convertibles there would be an even more exclusive group of final cars, two hundred to be exact. Called the Bicentennial model, each was finished in the same color scheme: white on white on white. Cotillion White paint, accented with thin red and blue pin

striping, white top, white wheel covers, and white upholstery. They also came with a special dash plaque to further guarantee their exclusivity.

1994 Ferrari 348CTS.

Naturally, Cadillac's decision to halt production became one of the top stories in every car magazine that year. Don Sherman's epitaph in the August 1976 issue of *Car and Driver* nailed it:

> *At least when America decides to leave the convertible business, we go out in a blaze of glory. The Cadillac Eldorado is one of the longest, biggest-engined, most expensive, and technically sophisticated machines ever to roll down an assembly line.*

When the absolutely last final convertible rolled off the line in Detroit at 10:12 A.M., on April 21, 1976, the desire to own one of these 14,000 cars, particularly the 200 Bicentennial models, had driven the price up to the $40,000 range. One man in Texas bought twenty-seven, another, a Michigan Cadillac dealer, managed to amass 290 of them. As for the "last convertible" itself, it was driven to Cadillac's corporate offices where it was put on display beside a 1903 Cadillac Model A and a 1931 V-16 phaeton.

As it turned out the convertible was not dead, it had just gone into hiding, waiting for a more favorable economic and political environment in which to make its comeback.

The wait would take six years and when it ended it was not General

The 1982 Chrysler LeBaron convertible.

As we began to get healthy again, I decided to bring back the convertible. As an experiment, I had one built by hand from a Chrysler LeBaron. I drove it over the summer, and I felt like the Pied Piper. People in Mercedes and Cadillacs started running me off the road and pulling me over like a cop. "What are you driving?" they all wanted to know. "Who built it? Where can I get one?"

When they recognized my now-familiar face behind the wheel, they would sign up for one right on the spot. I drove to my local shopping center one day, and a big crowd gathered around me and my convertible. You would have thought I was giving away $10 bills! It didn't take a genius to see that this car was creating a great deal of excitement.

Back at the office, we decided to skip the research. Our attitude was: "Let's just build it. We won't make any money, but it'll be great publicity. If we're lucky, we'll break even."

But as soon as word got out that we were bringing out a LeBaron convertible, people all over the country started putting down deposits. One of them was Brooke Shields, and we delivered the very first one to her as a special promotion. By then it was clear that we'd be selling quite a few of these babies. Turned out, we sold 25,000 the first year instead of the three thousand we had planned.

Before long, GM and Ford were bringing out convertibles of their own. In other words, little old Chrysler was now leading the way instead of bringing up the rear.

1986 Corvette. The return of the ragtop 'vette.

Motors or Ford who first made the decision to go topless, it was Chrysler and its gregarious chairman, Lee Iacocca.

In truth, Buick's Riviera convertible debuted at about the same time, but to most of the public it was Chrysler who brought the ragtop back. Within a year, Chevy and Ford had new drop-tops in the showrooms, followed in 1984 by Pontiac and Cadillac. Cadillac's return, after all the hoopla surrounding its "last convertible" in 1976, got some people pretty bent out of shape, people who had bought in 1976 for outrageous sums

Above: The 1999 MX-5 Miata. The little car that could, and did.

Right: The 1989 Dodge Viper V-10 concept vehicle. The Viper's vibes were all about power. Even today, some ten years after its first appearance as a show car, the "Zero to jail in four seconds," message is still loud and clear.

of money in hopes of cashing in at some future date. A group of them went so far as to file a class-action suit against Cadillac for destroying their investments, but it never went anywhere.

By the end of the 1980s there were eight convertible models available in Big Three dealer showrooms, with total domestic production hovering around 150,000 units in 1989. The convertible was back and headed into the 1990s in good shape.

During the decade's first couple of years, the sales leaders, as expected, were the Chrysler LeBaron and Ford Mustang convertibles, but then something unexpected happened. A new car with a new name jumped to third, outpacing the fourth place Mercury Capri by a margin of more than two to one. It was called the Miata. Made in Japan by Mazda, it became the immediate darling of the automotive press and nearly everyone else. It was cute, quick, relatively inexpensive, and it took the newly reborn convertible market and stood it on its ear. Other than the venerable Corvette and a few low-volume imports, the convertible of the 1990s had been the traditional four-passenger vehicle. The Miata heralded the return of the true two-seat sports car. It was a sensation. Its initial reception was reminiscent of the response given the original T-Bird, and one that quickly got the attention of the suits in the corporate suites.

Were it not for the immediate, overwhelming success of the Miata, it's doubtful that roadsters such as the BMW Z3, Porsche Boxster, Mercedes SLK, Dodge Viper, or Plymouth Prowler would have gone into production. They'd probably have made the tour of the international auto show circuit and then been retired to wherever it is that old dream cars go to these days.

The "dream," "experimental," "idea," "show," or "concept" car first came into being back in 1938 when General Motors' flamboyant vice president of styling, Harley Earl, designed a car he called the "Y-Job." He

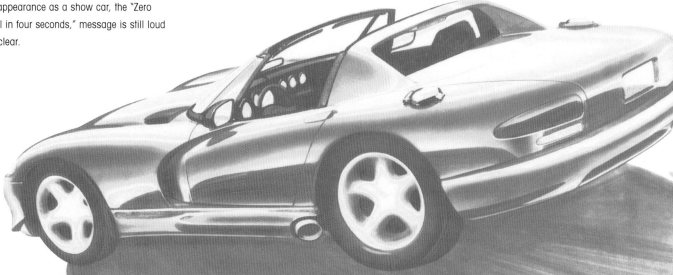

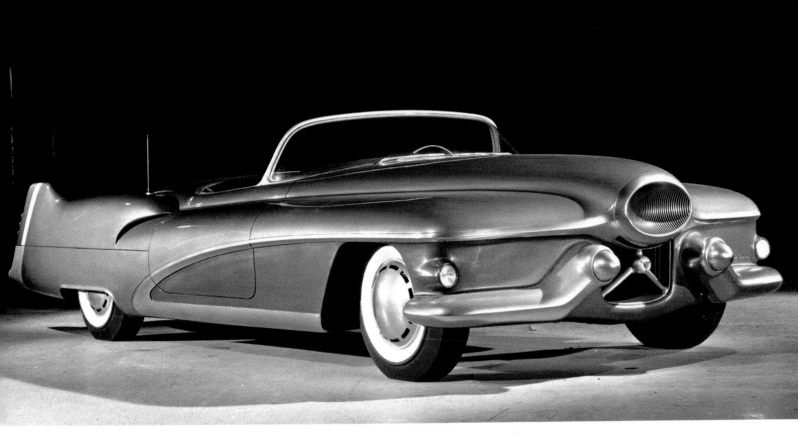

named it the Y-Job because the letter Y was the designation used by the aviation industry during World War II for experimental aircraft. Earl, who would later introduce the automobile tail fin, was fond of telling interviewers, "I dream automobiles."

The Y-Job, which was the obvious precursor of GM's postwar convertible line, was the first car with power windows and a power convertible top. Two years later, Chrysler and its coachbuilding partner, LeBaron, jumped into the dream car market in a big way with the Thunderbolt and the Newport dual-cowl phaeton. Both cars featured retractable hardtops that disappeared into the bodywork, along with a host of other electrically operated gadgets that earned them the nickname "push-button" cars. From that point on, the dream car became a staple of every automobile show, drawing wide-eyed little boys of all ages to the manufacturer's exhibit space where, hopefully, they could be persuaded to purchase something in the reality line.

Dream cars allowed the automakers to assess the potential buyer's reaction to various styling and mechanical innovations without the huge

The 1951 Buick LeSabre. Another of Harley Earl's designs, the jet-influenced LeSabre featured a top that closed automatically whenever rain fell on an electronic sensor located between the seats.

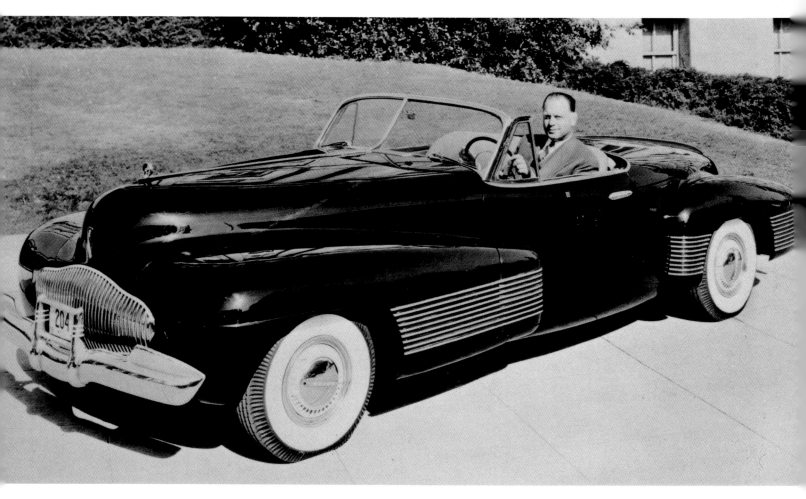

The 1938 GM Y-Job and its designer, Harley Earl.

expenses entailed by putting them into production vehicles. In fact many, if not most, of the dream cars put on display were nothing more than full-size model cars without an engine or drive-train. But by the mid-1980s, the show car had also become a "go" car. Static models would no longer suffice. In fact it was not that unusual to find road tests of the latest show cars in the automotive enthusiast press. Chrysler quickly took the industry lead with its ability to convert concepts into reality. The popularity of the Dodge Viper and Plymouth Prowler show cars has translated directly into success in the marketplace while the Dodge Copperhead seems poised to become the next dream headed for the showroom. Interestingly, when it came time to produce these dreams on wheels, they all turned out to be convertibles.

As more and more Americans choose the sport utility vehicle, mini-van, or pickup truck for their primary mode of transportation, the sales

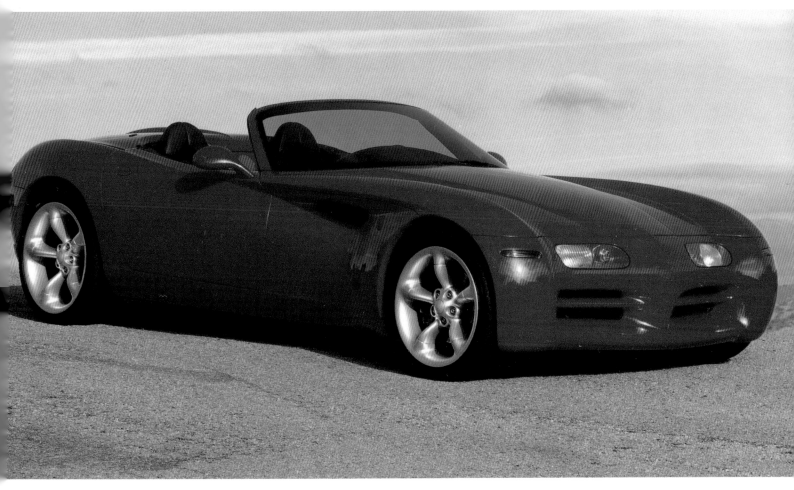

The 1999 Dodge Copperhead concept vehicle.

potential of the sporty, fun-to-drive, wind-in-your-face roadster will only increase. Need it be said that fun is the operative word here?

On your next highway jaunt, take a close look at the drivers of those big four-wheel-drive behemoths, then compare what you see with the folks behind the wheel of any one of the new breed of roadsters. You might encounter them on the Long Island Expressway, the Golden State Freeway, or some lonely stretch of blacktop. But, if it's a sunny day, full of cloudless blue skies, I'd bet that most of those drivers look as though they're headed "somewhere west of Laramie" in a Jordan Playboy.

Years ago, British Leyland, in an ad for the Triumph TR-7, managed to sum up in a very few words the thing about convertibles that makes people want to sing their praises, paint their pictures, write their stories, or just kick back, drop the top, and hit the highway: *Headroom: 93 million miles.*

SELECTED BIBLIOGRAPHY

Books

Anderson, Rudolph E. *The Story of the American Automobile.* Washington, D.C.: Public Affairs Press, 1950.

Auto Editors of Consumers Guide. *The Great American Convertible.* Lincolnwood, Illinois: Publications International, 1991.

Benson, Michael. *Convertibles: Sun, Wind & Speed.* New York: Smithmark Publishers, 1996.

Boyne, Walter J. *Power behind the Wheel.* New York: Stewart, Tabori & Chang, 1988.

Collins, Max Allan, and Drake Elvgren. *Elvgren, His Life and Art.* Portland, Oregon: Collectors Press, 1998.

Dauphinais, Dean D., and Peter M. Gareffa. *Car Crazy.* Detroit, Michigan: Visible Ink Press, 1996.

Fetherston, David. *Woodys.* Osceloa, Wisconsin: Motorbooks International, 1995.

Flink, James J. *America Adopts the Automobile, 1895–1910.* Cambridge, Massachusetts: MIT Press, 1970.

Flink, James J. *The Automobile Age.* Cambridge, Massachusetts: MIT Press, 1990.

Gunnell, John "Gunner." *Convertibles, The Complete Story.* Blue Ridge Summit, Pennsylvania: Tab Books, 1984.

Hirsch, Jay, and Warren Weith. *The Last American Convertibles.* New York: Collier Books, 1979.

Hodges, David, David Burgess-Wise, John Davenport, and Anthony Harding. *The Guinness Book of Car Facts & Feats.* London: Guinness Publishing, 1994.

Ikuta, Yasutoshi. *The American Automobile.* San Francisco: Chronicle Books, 1988.

Janicki, Edward. *Cars Detroit Never Built.* New York: Sterling Publishing Co., 1995.

Jewell, Derek, ed. *Man & Motor: The Twentieth Century Love Affair.* New York: Walker and Company, 1967.

Kuah, Ian. *Convertibles.* New York: Smithmark Publishers, 1993.

Newbery, J. G. *Classic Convertibles.* New York: Smithmark Publishers, 1995.

Oppel, Frank, ed. *Motoring in America.* Secaucus: Castle Books, 1989.

Pettifer, Julian, and Nigel Turner. *Automania.* Boston: Little, Brown and Company, 1984.

Robson, Graham. *The A-Z of Classic Convertibles.* London: New Burlington Books, 1988.

Scharff, Virginia. *Taking the Wheel.* New York: The Free Press, 1991.

Sears, Stephen W. *The American Heritage History of the Automobile in America.* New York: American Heritage Publishing Co., 1977.

Silk, Gerald. *Automobile and Culture.* New York: Abrams, 1984.

Tubbs, D.B. *Art and the Automobile.* New York: Grosset & Dunlap, 1978.

Tuska, John. *The Filming of the West.* Garden City, New York: Doubleday & Company, 1976.

Wieder, Robert and George Hall. *The Great American Convertible.* Garden City, New York: Doubleday & Company, 1977.

Williams, Jim. *Boulevard Photographic: The Art of Automobile Advertising.* Osceola, Wisconsin: Motorbooks International, 1997.

Witzel, Karl Michael, and Kent Bash. *Cruisin', Car Culture in America.* Osceola, Wisconsin: Motorbooks International, 1997.

Wright, Nicky. *Classic Convertibles.* New York: MetroBooks, 1997.

Periodicals/ Newspapers

AFAS Quarterly, Arts & Antiques, Automobile, Automobile Quarterly, Car Collector & Car Classics, Car and Driver, Car Life, Cigar Aficionado, Classic Automobile Register, Corvette Quarterly, Road & Track, Special Interest Autos, Sport Aviation, Vintage Motorsport

Russell von Sauers, *1924 Hispano Suiza*, 1998.

The author regrets any omissions or inaccuracies in identifying the sources and permissions. Please advise the publisher of any corrections, and they will be made in future printings.

TEXT SOURCES/ PERMISSIONS

Angel of Darkness by Caleb Carr. © 1997 by Caleb Carr. Reprinted with permission of Random House, Inc. *Auto Opium* by David Gartman. © 1994 by David Gartman. Reprinted with permission of Routledge, Ltd. *Cars of the Stars* by Jack Scagnetti and George Barris. © 1974 by Jack Scagnetti and George Barris. Jonathan David Publishers. Reprinted with permission of the author. *Chitty-Chitty-Bang-Bang* by Ian Fleming. © 1964 by Glidrose Productions, Inc. Reprinted with permission of Random House, Inc. *Confessions of a Fast Woman* by Lesley Hazleton. © 1992 by Lesley Hazleton. Addison-Wesley Publishing Company. Reprinted with permission of the author. *Crash* by J. G. Ballard. © 1973 by J. G. Ballard. Reprinted by permission of Farrar, Straus & Giroux, Inc. USA, and Vintage, Random House, London. Reproduced by permission of the author c/o Margaret Hanburry, 27 Walcot Square, London SE114UB. *Driving Passion* by Peter Marsh and Peter Collett. © 1986 by Peter Marsh and Peter Collett. Reprinted with permission of Random House/Jonathan Cape. *Everything Women Always Wanted to Know about Cars* by Lesley Hazleton. © 1995 by Lesley Hazleton. Doubleday, a division of Bantam Doubleday Dell Publishing Group, Inc. Reprinted with permission of the author. *The Great Gatsby* by F. Scott Fitzgerald. © 1925 by Charles Scribner's Sons; renewal © 1953 by Frances Scott Fitzgerald Lanahan. *Highways to Heaven* by Christopher Finch. © 1992 by Christopher Finch. Harper Collins Publishers, Inc. *Hiro Yamagata, Earthly Paradise.* Introduction by Allen Ginsberg. © 1994 Allen Ginsberg. Reprinted with permission of the Wylie Agency. Journey Editions an imprint of Charles E. Tuttle Company, Inc. *Iacocca: An Autobiography* by Lee Iacocca with William Novak. © 1984 by Lee Iacocca. Used by permission of Bantam Books, a division of Bantam Doubleday Dell Publishing Group, Inc. *James Dean, The Untold Story of a Passion for Speed* by Philippe Defechereux and Jean Graton. © 1995 by Graton Editeur S.A., 1996 by Mediavision Publications, Inc. Reprinted with permission of Graton Editeur S.A. and Mediavision Publications, Inc. *The Last Convertible* by Anton Myrer. © 1978 by Anton Myrer. Permission granted by the Estate of Anton Myrer, c/o McIntosh & Otis, Inc. *"Second Chance,"* from *About Time* by Jack Finney. © 1986 by Jack Finney. Reprinted with permission of Simon & Schuster. "Women in Cars" by Martha McFerren. © 1992 by Martha McFerren. Helicon Nine Editions. Reprinted with permission of the author. *The World's Number One, Flat-Out, All-Time Great, Stock Car Racing Book* by Jerry Bledsoe. © 1975 by Jerry Bledsoe. Reprinted with permission of Doubleday, a division of Bantam Doubleday Dell Publishing Group, Inc.

MUSIC PERMISSIONS

"Freeway of Love" by Jeffrey Cohen and Narada Michael Walden. Published by See No Evil Music/When Worlds Collide Music and WB Music Corp/ Gratitude Sky Music. "No Money Down" by Chuck Berry. © 1955 by Chuck Berry. Published by Isalee Music Co. "Pink Cadillac" by Bruce Springsteen. © 1984 by Bruce Springsteen. Reprinted by permission. "Reno Bound" words and music by John McFee and Andre Pessis. © Long Tooth Music/ Endless Frogs Music. Published by Bob-A-Lew Songs' and Wixen Music Publishing, Inc.

PICTURE CREDITS

Volkmer Albers, Ferrari of Central Florida, page: 16 bottom right. Auburn Cord Dusenberg Museum, pages: 48, 57 bottom. Automobile Quarterly, pages: 18, 81, 85 left, (24, 35 left and bottom, Don Vorderman), (35 top right, L. Scott Bailey), (43, 50, 98, Roy Query), (99, Rick Lenz). Leslie-Jean Bart, pages: 31, 32 left, 33, 69 top and bottom. Chrysler Historical Collection, pages: 36, 55, 108, 110 bottom, 113. Collectors Press, Inc., page: 46 top. Corbis-Bettman, pages: 19, 22, 23 right, 28, 49, 67, 72, 73. Culver Pictures, pages: 14, 21, 26, 32 top, 34, 37 top, 44, 79, 85 right. Danny Peary Collection, page: 57 top. Daytona Racing Archives, pages: 90, 91 top and bottom. Exoticar Model Company, page: 94 right. General Motors Corp., (c) 1978. Used with permission of GM Media Archives, pages: 17, 42, 61, 102, 106, 111, 112. Martyn Goddard, pages: 2–3, 95 left, center, right, 96. David Gooley, Special Interest Autos, page: 10 top. Grandma Moses Properties, page: 10 bottom. "Grandma" Moses (1860–1961), the most popular American folk artist of this century, began painting while in her seventies; her works celebrate rural traditions and community life. Graton Editeur S.A. and Mediavision Publications, Inc., page: 74. Jay Hirsch, pages: 29, 41, 54, 56, 104, 107, 109. Hugh Gordon Collection, pages: 82, 83. Jamie B. James Collection, page: 40. Mazda Information Bureau, page: 110 top. Mickey McGuire, pages: 1, 16 left. Peter Vack Collection, page: 47. Reuters/ Bettman Newsphotos, page: 37 far left. Douglas Sandberg, page: 97. Taylor-Constantine, Special Interest Autos, page: 80 top. UPI Bettman News Photos, page: 78. UPI Photos, page: 37 left. UPI/Corbis-Bettman, pages: 77 bottom, 84.

Russell von Sauers, *1959 Cadillac,* 1998.

Russell von Sauers, *1963 Morgan 4/4,* 1998.

ACKNOWLEDGMENTS

No book that draws on as many sources as this one has would be possible without the support and good will of a great many people. Although not an alphabetical listing, I'll start with *Automobile Quarterly*, the ultimate resource for automotive history, with special thanks to Jonathan Stein, Karla Rosenbusch, Jennifer Reimert, and Jennifer Bunker. The sushi irregulars, Mark Wallach, Fred and Dan Kanter, Philippe Defechereux, Jim Bardia, Dennis Nash, and Bruce Stark. David Truong. Lesley Hazleton. Micky McGuire. Jack Scagnetti. Martha McFerren. Terry and Eva Herndon. Cara Sutherland. Scott Chinery. Jamie B. James. Merrideth Miller, The Cartoon Bank. Dave Brownell and Nancy Bianco, Special Interest Autos. Jacques Vaucher, l'art et l'automobile Gallery. Carl Goodwin. Peter Vack. Hugh Gordon. Bruce Wennerstrom. Art Ponder, Chrysler Historical Collection. Cymbrie Trepczynski, GM Media Archives. Karen Prymak, American Automobile Manufacturers Association. Richard Perry and Lisa Perry, Collectors Press. John Mauk, Daytona Racing Archives. Yvonne Shine, Exoticar Model Co. Danny Peary. Douglas Sandberg. Paul Russell. Carol Adamczyk, Motorbooks International. Ann Barbaro, Grandma Moses Properties. Caroline Donohue and Liz Kane, Dooney & Bourke. Carol Butler and Kelly Hill, Elvis Presley Enterprises. Robin Zlatin, New Line Cinema. Peter Tomlinson, Culver Pictures. Norman Currie, Corbis-Bettman. Randall Wixen, Wixen Music Publishing. Ginger Freers, Bob-A-Lew Music. Jon Landau Management. William Krasilovsky, Isalee Music Co. The Petersen Museum. The Auburn Cord Duesenberg Museum. Volkmer Albers, Ferrari of Central Florida. Hill & Knowlton. My good friends Leslie Jean-Bart, Russell von Sauers, and all of the other artists whose work graces these pages: Harrod Blank, Dennis Corrigan, Tom Hale, Alain Levesque, Jay Hirsch, R. Kenton Nelson, Chuck Queener, Martyn Goddard, Jean Taylor-Constantine, Stanley Wanlass, Nicola Wood, and Hiro Yamagata. Finally, I'd like to thank Christine Tomasino, my nonpareil agent, my editor, Jay Schaefer, Steve Mockus, Nion McEvoy, and the rest of the staff at Chronicle Books for making this yet another great publishing experience.

Following page: R. Kenton Nelson, *The Motoring Richmonds,* 1997.

Below: Russell von Sauers, 1956 Mercury Montclair, 1998.